mini
house

HarperCollins books may be purchased for educational, business, or sales promotional use.
For information, please write: Special Markets Departments, HarperCollins*Publishers* Inc.,
10 East 53rd Street, New York, NY 10022.

Third Paperback Edition

First published in 2002 by:
Harper Design International
An Imprint of HarperCollins*Publishers*
10 East 53rd Street
New York, NY 10022
Tel: (212) 207-7000
Fax: (212) 207-7654
collinsdesign@harpercollins.com
www.harpercollins.com

Distributed throughout the world by:
HarperCollins International
10 East 53rd Street
New York, NY 10022
Fax: (212) 207-7654

Executive Editor: PACO ASENSIO
Editorial coordination: ALEJANDRO BAHAMÓN
Art direction: MIREIA CASANOVAS SOLEY
Graphic design and layout: PILAR CANO
Copy-editing: FRANCESC BOMBÍ-VILASECA
Translation: WENDY GRISWOLD

Library of Congress Control Number: 2004113270

ISBN: 978-0-06-079220-6

Printed by: LIBERDÚPLEX S.L., BARCELONA. SPAIN

Third Paperback Printing, 2009

mini house

ALEJANDRO BAHAMÓN

COLLINS DESIGN

An Imprint of HarperCollinsPublishers

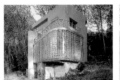
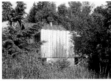
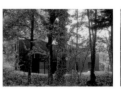
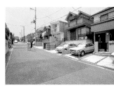

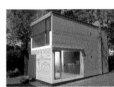
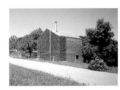
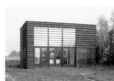
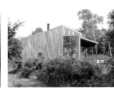
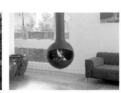

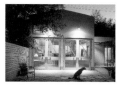
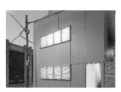
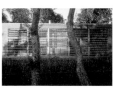
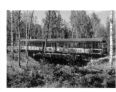
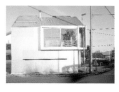
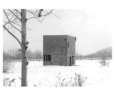
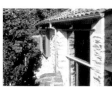
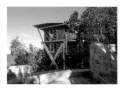
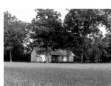
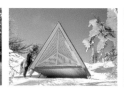
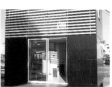
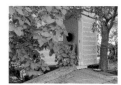
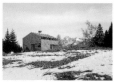

| Alejandro Bahamón |

The relationship between public and private space depends on the architectural features that define one and surround the other. According to the purpose of each building, this boundary can be made more diffuse, to the point of having a vast series of interior spaces that are considered public. But in the end, the house is the final refuge, the true physical definition of that which is private. In addition to affording protection to its inhabitants, whether from inclement weather or social conditions, the house becomes an extension of its inhabitants' personalities. Given the privacy with which we live inside it, it is perhaps the man-made space that we most appropriate and that has the strongest identity. This privacy is protected from that which is public by various mechanisms that establish a gradation between one area and the next.

The traditional house layout, inherited from the earliest civilizations, calls to mind front gardens, foyers, courtyards, corridors, galleries – in short, preludes to the more private spaces. But when,

AN ARCHITECT, RELYING ON TECHNOLOGY AND THE CURRENT NECESSITIES, IS CAPABLE OF PRODU-

as architects, we confront the problem of designing a minimal house, it becomes entirely an exercise in making all these preludes disappear, and clear, forceful strategies are needed to separate or connect these two worlds.

The minimal – meaning tiny – house has been a recurring theme in architecture, whether as an academic exercise or as a spontaneous vernacular response to man's basic need for shelter. Examples range from Native American tents

CING A SMALL ARCHITECTURAL OBJECT THAT IS
BOTH GREATLY PRODUCTIVE AND EFFICIENT.

to the Kolonihaven contemporary architecture park in Denmark, which has served as a theoretical framework for aesthetic thought on small homes. This collection of 26 structures includes practical contemporary specimens, not exceeding 120 square meters, that demonstrate countless architectural solutions for houses with minimal space.

The design of a minimal house has to solve very diverse problems, from form and function to the structural system and technical definitions. The resolution of these problems in a building of small proportions results in various highly precise, efficient objects. First, the basic functions of the house have to be established, as well as those most important to the client, in order to simplify the task as much as possible. It is often necessary to resort to mechanisms or components that serve two or more functions at the same time, thus optimizing the usable space. From a formal standpoint, the minimal house must be based on a very rational plan. Pure shapes, generally orthogonal, adapt best, since they optimize the use of space. Inside, divisions created by walls are avoided to the maximum possible extent. In addition to taking up space, walls make the area seem smaller. Conversely, single, open, continuous spaces, which accommodate most of the functions, are sought. Due to the structure's proportions, which are also

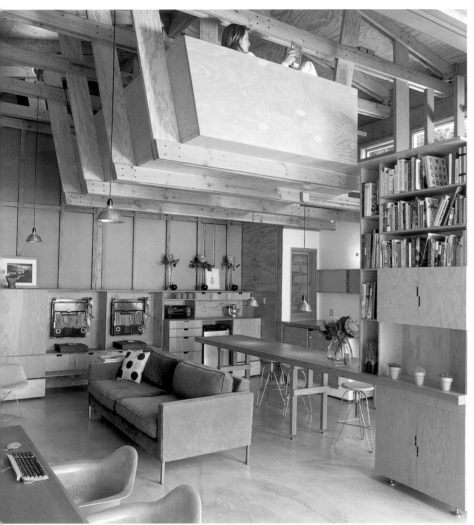

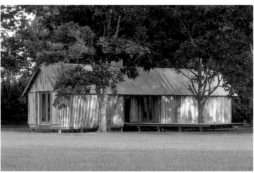

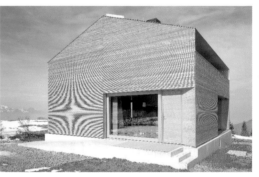

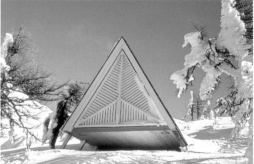

space possible. Found inside these homes are ingenious elements such as folding tables, hanging beds, translucent panels, and highly-efficient storage areas. So we have a sampling in descending order, down to the home of just 32 square meters, in which the analogy to compact appliances is inevitable. Modern technology has minimized everything from modes of transport to computer systems, combining their components in increasingly precise and sophisticated ways. As modern machines have microchips that hold vast amounts of data, architects have very thin materials to replace those that one took up a great deal more space. There are thin metal sections that serve as structural systems, plywood systems that provide the final finish for surfaces, and very dense, very thin materials that provide thermal and acoustic insulation. In this respect, today's architect, supported by technology and current needs, can produce a high-quality, efficient structure. This is reflected in spaces that do not sacrifice a large dose of creativity and design sophistication to their minimal size.

related to the budget for the project, minimal houses tend to use a basic, light structural system, generally based on wooden frames or thin metal sections, which also make the building easy to construct on isolated or inaccessible plots of land. Moreover, many highly-sophisticated technical details make a multifunctional interior

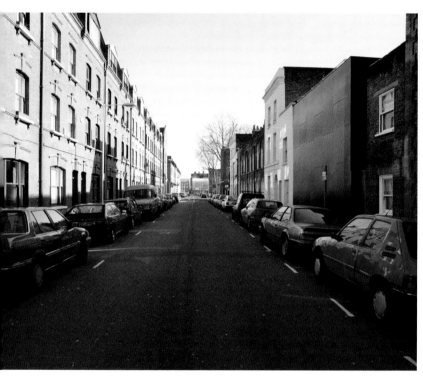

While the house's contemporary appearance is the result of the materials and formal language used, the building is totally integrated with the neighboring houses. The dimensions of the building and the proportions of the pieces that comprise the façade are a based on the surrounding Victorian architecture.

Elektra

LONDON, UNITED KINGDOM 2001 ARCHITECT: **DAVID ADJAYE** PHOTOGRAPHER: © **LYNDON DOUGLAS** AREA: **1,291** SQ. FEET

The architect's concept was to build a house within a house in order to take advantage of the existing elements. Having bought an old belt factory in London's East End, an eclectic, industrial neighborhood, the owners decided to restore it for use as a home. The new building uses the foundations and outer walls of the old factory, but new metal framework was inserted in the interior, to create an upper floor, which is used as a sleeping area. The façades are suspended from the metal structure, minimizing the load on the existing foundations.

The front of the house faces north, and was conceived as an isolated façade without formal expressiveness. The exterior is finished with the type of resin-covered plywood panels generally used to make concrete forms. These panels are laid out in a pattern that identifies with the windows of the neighborhood houses.

The material was left in its natural state, and is reminiscent of polished bronze. At the end of a group of typical East End semidetached houses, this building is bright with smooth textures, in contrast to the surrounding Victorian brick architecture.

The façade's lack of ostentation is reflected in the interior, where a two-story space with a skylight runs the entire length of the house. This space acts as a solar fireplace for the flexible area used as living or work space. The rear, which faces south and takes advantage of the interior garden on the block, is completely open, due to a large glass surface. On this side of the building another two-story space allows light to filter through to the interior of the ground floor.

DAVID ADJAYE
House

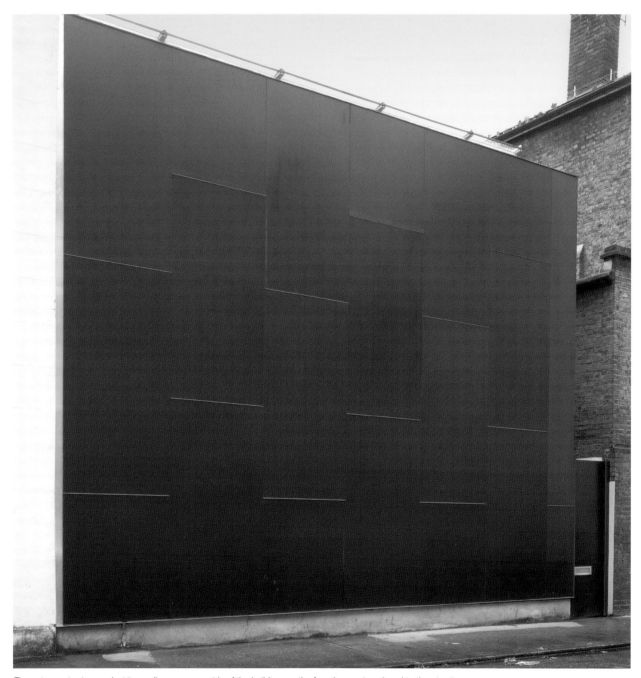

The entrance is via a pedestrian walkway on one side of the building, so the façade remains closed to the street.

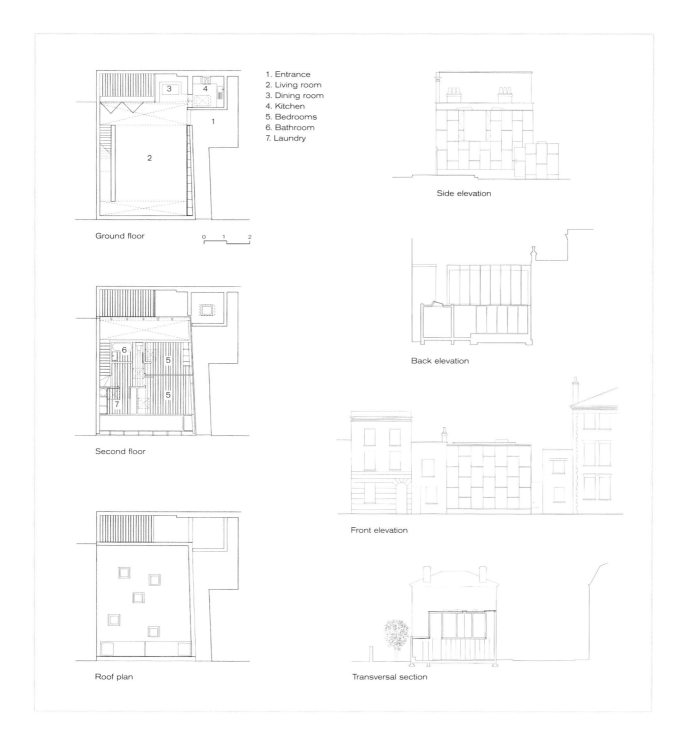

1. Entrance
2. Living room
3. Dining room
4. Kitchen
5. Bedrooms
6. Bathroom
7. Laundry

Ground floor

Second floor

Roof plan

Side elevation

Back elevation

Front elevation

Transversal section

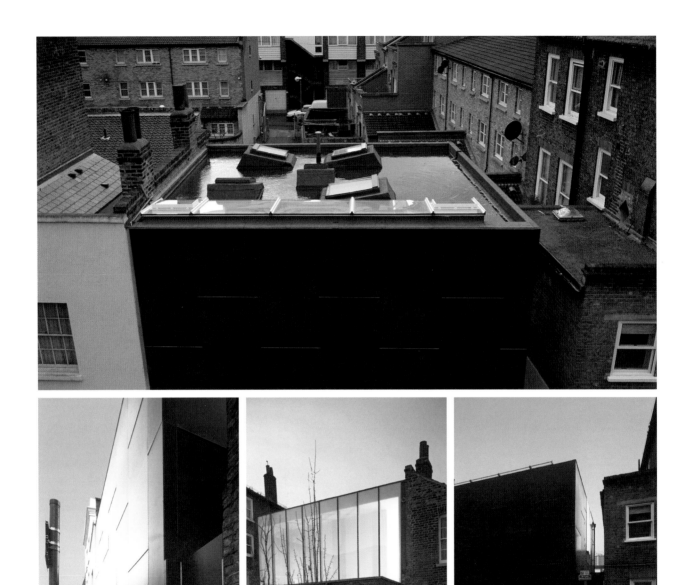

Seeking the greatest possible light in the rear, large glass plates were anchored to slender aluminum frames supported by a large metal beam that links the two sides of the building.

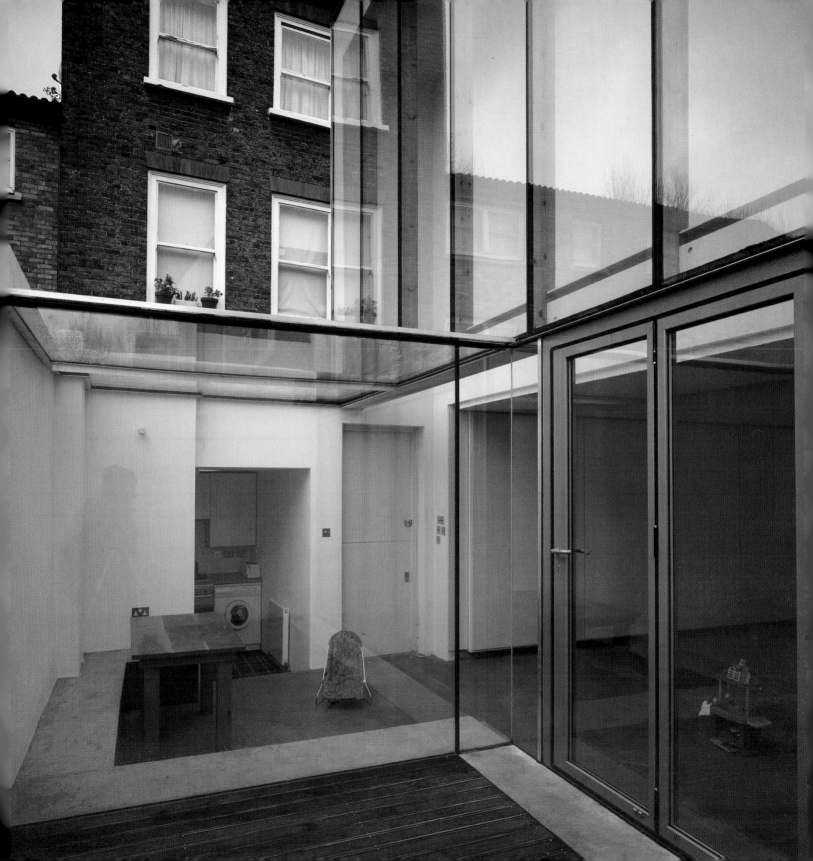

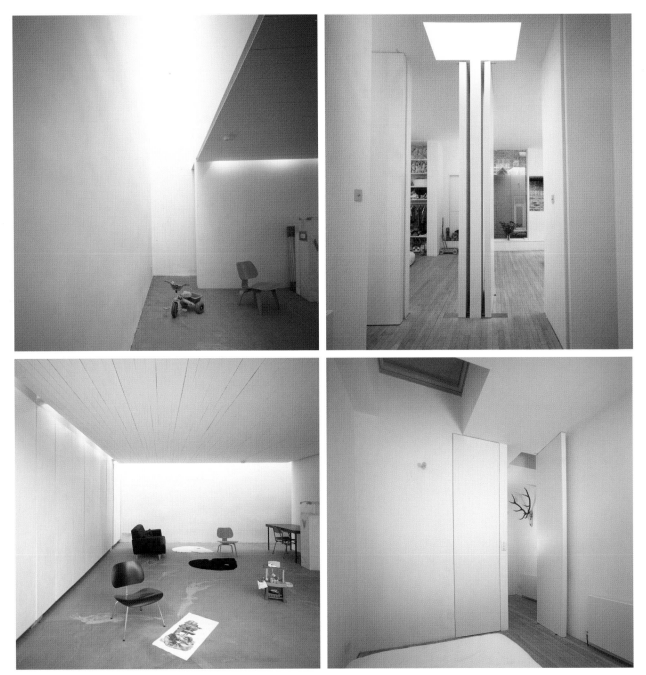

This project has reversed the traditional idea of windows illuminating a room. Here, the reflection, brightness, and movement of light become real experiences in the interior.

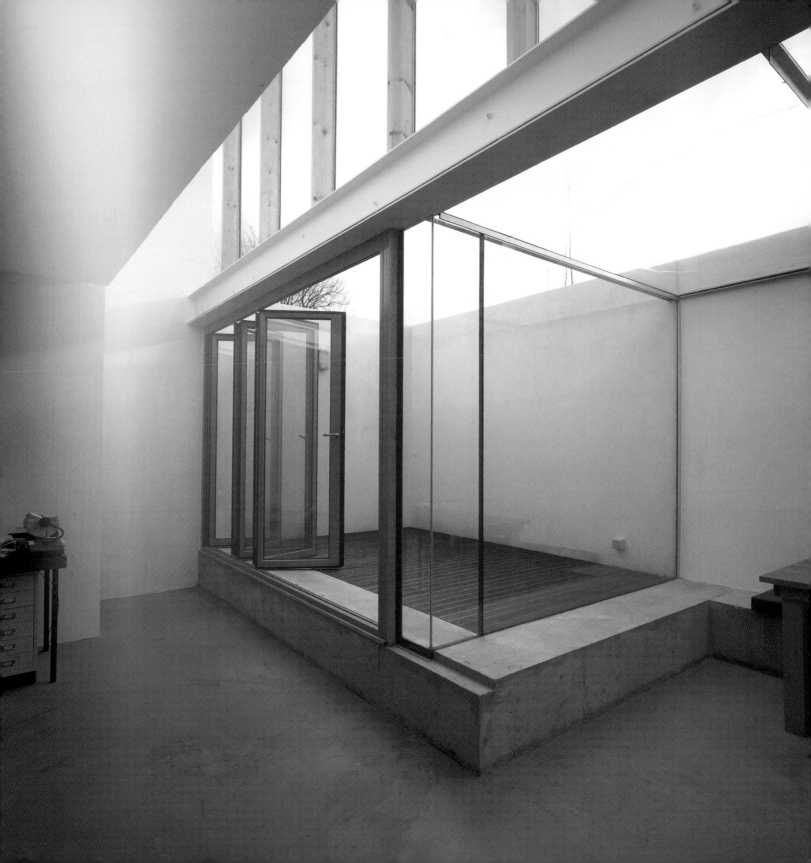

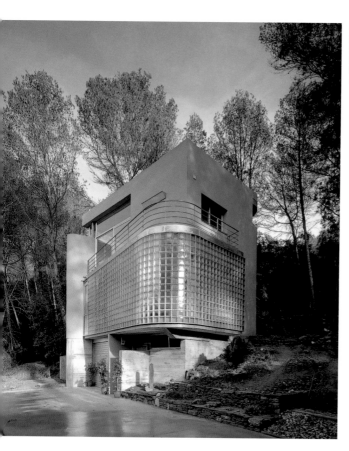

A structure built with glass, metal, and concrete contrasts the rural setting where traditional rustic building materials predominate.

House in

Torrelles de Llobregat, Barcelona, Spain 1999 Architect: **Rob Dubois** Collaborators: **Shuichi Kobari Arquitectos** Photographer: © **Jordi Miralles** Area: **1,291 sq. feet**

This compact vacation home on the outskirts of Barcelona, Spain, reflects the fragility of its setting. Despite the dense woods and splendid natural panoramas, the area is highly vulnerable as a result of its geological features and proximity to the heavy urban development of Barcelona. This tiny house, with its vertical design, was placed very close to the road on the northern end of the lot, mitigating its impact on the terrain. This step minimized the amount of excavation required and compressed the building as much as possible, producing the slightest possible visual impact on the surroundings.

The geometry of the building is based on two wedges framing a rectangle. Located at the ends of the house, the wedges are used for the kitchen and bathrooms, while the rectangle includes the living room and bedrooms. The formal language of the house is enriched by the relationship between the rectilinear shapes of the central unit and the curves at the ends. Aligning the main rooms with the longitudinal axis of the plot allowed for long, sweeping views of the immediate area and the valley to the north.

The house has three floors which connect the lower and upper levels of the site. Pedestrian access is on the upper floor, by means of a light metal staircase that leads to a narrow catwalk which doubles as a balcony. Here we find the living room, dining room, and kitchen. The cylindrical unit on the southern side of the house encloses a spiral staircase that leads to the lower floors. On the ground floor are the two bedrooms, while the basement level provides parking and contains a small office.

Rob Dubois
Torrelles

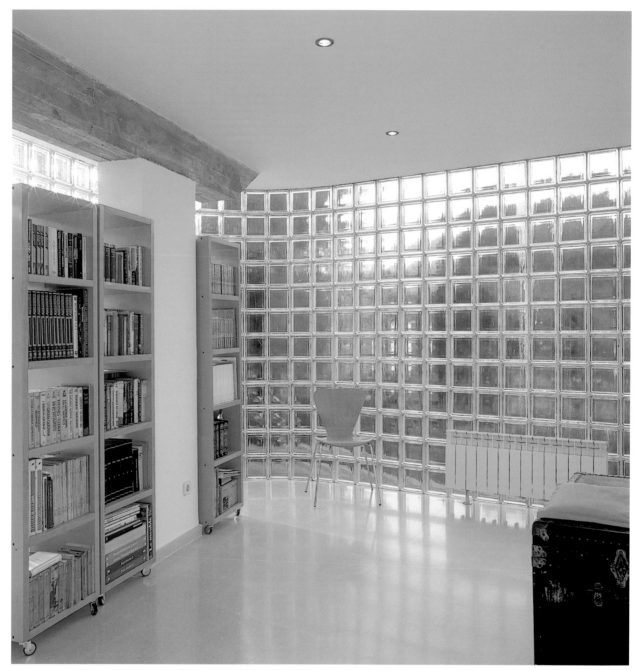

The contrast between the closed surfaces, that conceal the service and traffic areas, and the large open spaces, behind which the living and sleeping areas are placed, enriches the appearance of the house.

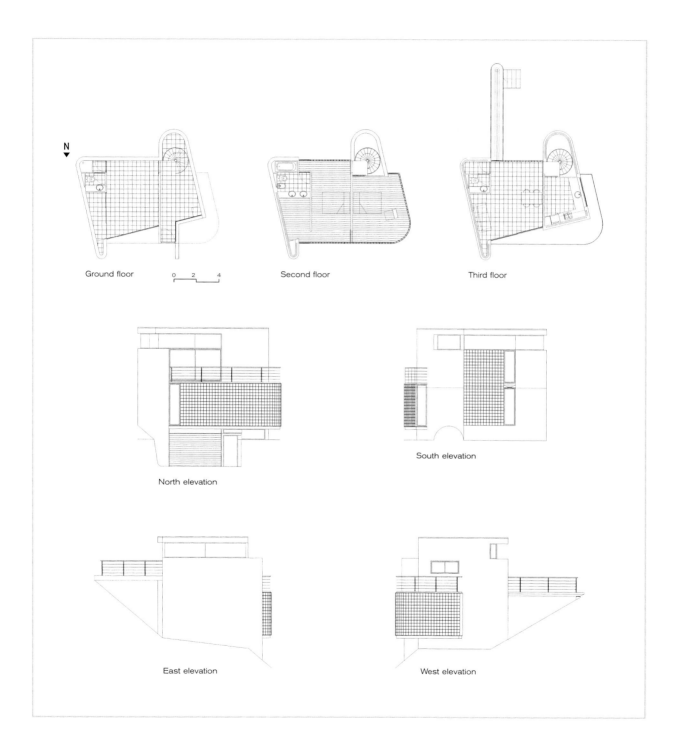

N

Ground floor 0 2 4

Second floor

Third floor

North elevation

South elevation

East elevation

West elevation

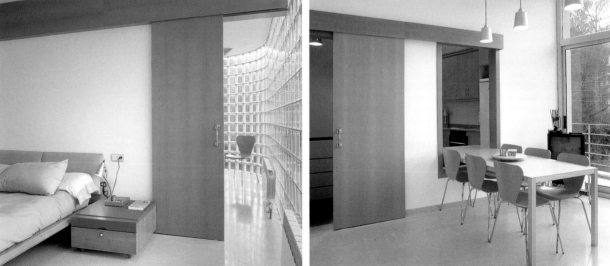

While the basement level access area has an enclosed feel, the pedestrian entryway area and catwalk are light, transparent, and integrated with the exterior.

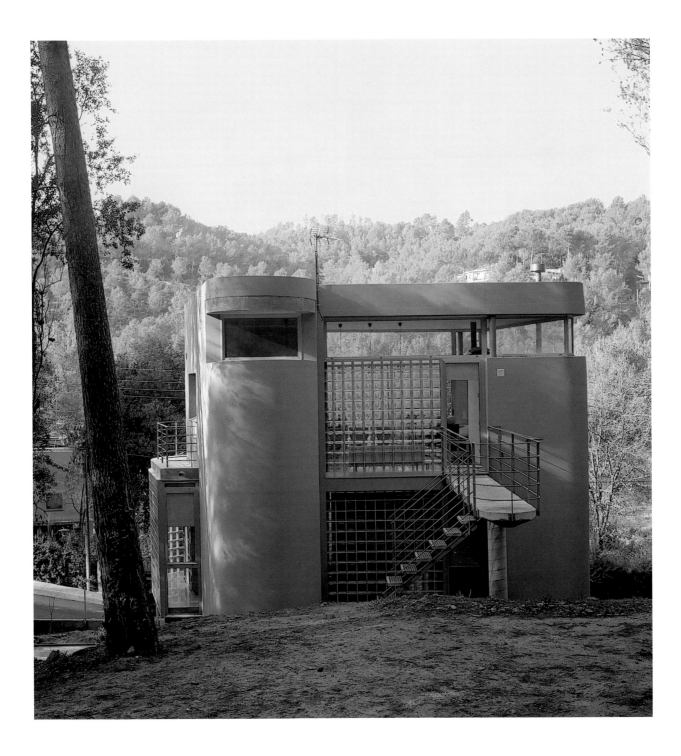

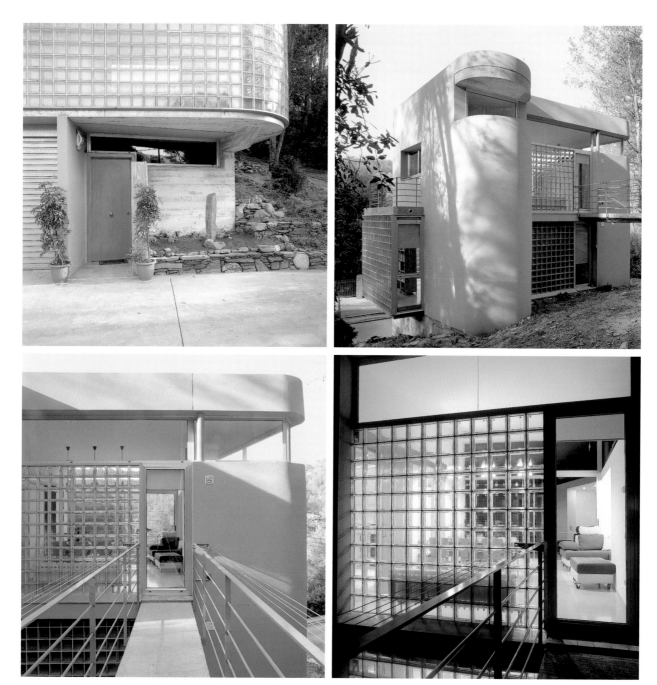

The finish of the outer walls, constructed with glass blocks, combines maximum illumination with a sense of privacy and interior security.

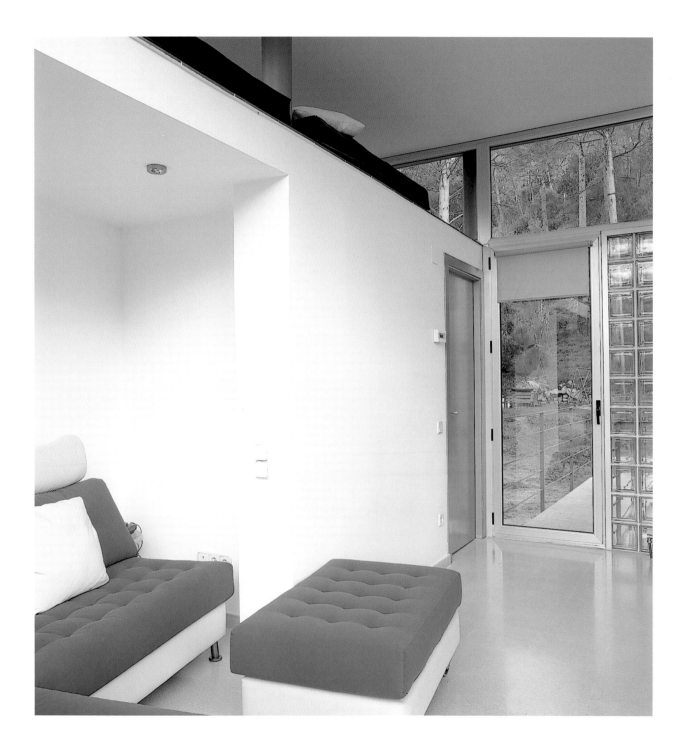

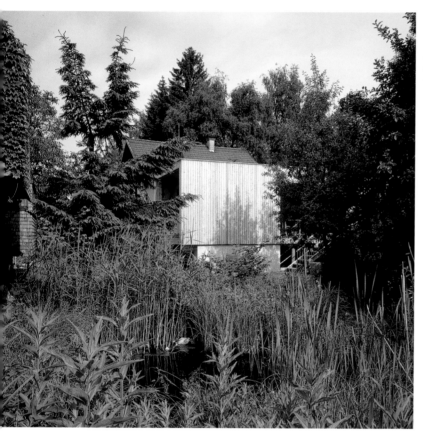

Despite its contemporary
appearance, this clean,
austere house blends
with the natural setting.
The use of wood as
the dominant material
emphasizes this
relationship.

Moosmann-

Lauterach, Austria 2002 Architect: **Hermann Kaufmann** Photographer: © **Ignacio Martínez** Area: **1,291 sq. feet**

The challenge of this project was to create a complete home for a young couple next to one spouse's parents' house, in a small part of the garden. The only place for a new structure was the narrow strip between the main house and the neighbors' house – hence the building's long shape. This placement allowed for a space between the old and new buildings that was used as a common entrance for both houses.

The land has a slight incline that is overcome by two box-like units anchored to the slope. On the upper floor, level with the street and the main entrance, is the social area of the house, with the living room, dining room, kitchen, and a bathroom all contained in a prefabricated wood structure. Slender metal stairs connect this area with the garden and the outdoor terrace. The lower story, slightly below ground level, contains the bedrooms and consists of a reinforced concrete box that serves as the foundation for the upper unit.

While the proportions and inflexibility of the location did not allow for the use of passive solar energy, systems that minimize energy consumption were incorporated. An integrated system that combines solar energy storage and a carefully thought out ventilation and heat recovery system ensures that the house is heated to average temperatures.

To enhance the feeling of spaciousness, the dividing walls stop short of the ceiling and do not come flush up against the structural walls. Red was used to highlight service elements, such as the kitchen furniture, the bathroom, and the closets, creating a contrast with the rest of the monochromatic materials.

Hermann Kaufmann
Hämmerle House

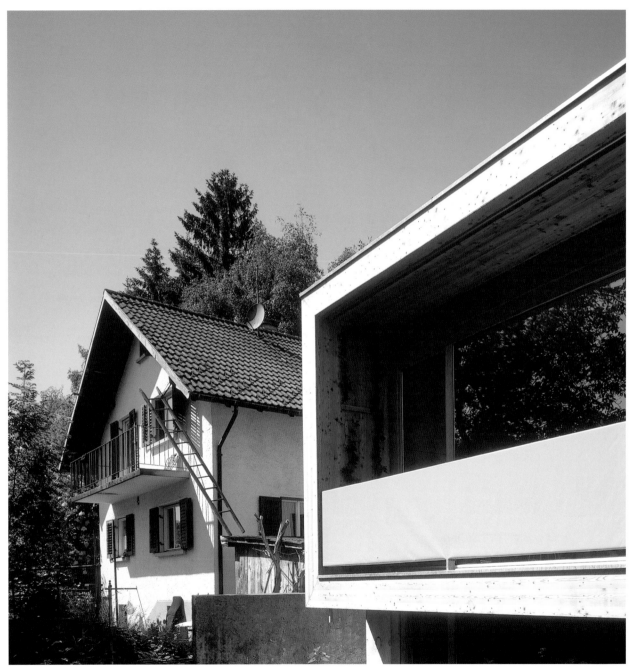

The upper unit, constructed of wood, is rounded off with a large window, resembling a screen, that opens onto an interior balcony with a view of the garden at the rear of the site.

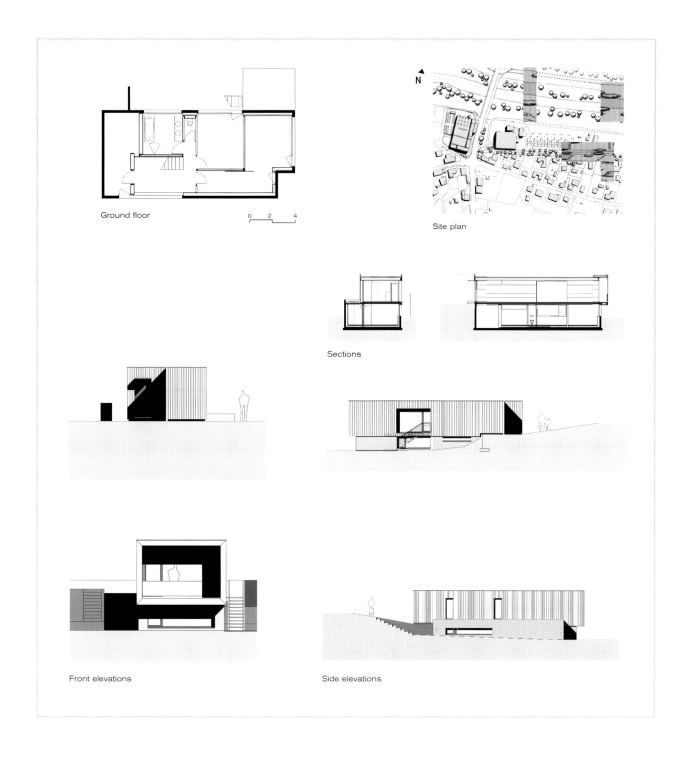

Ground floor

0 2 4

Site plan

Sections

Front elevations

Side elevations

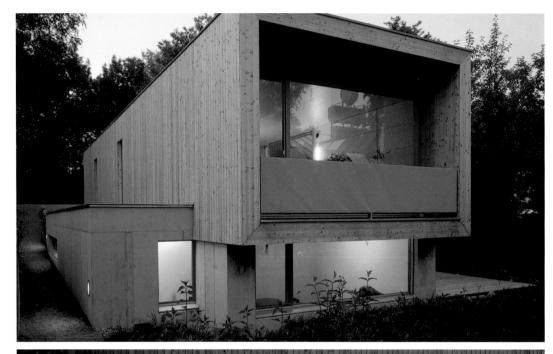

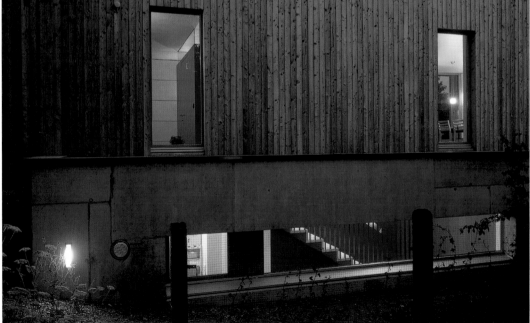

In contrast to the rear, the façade on the entry side looks like a modest, closed unit.

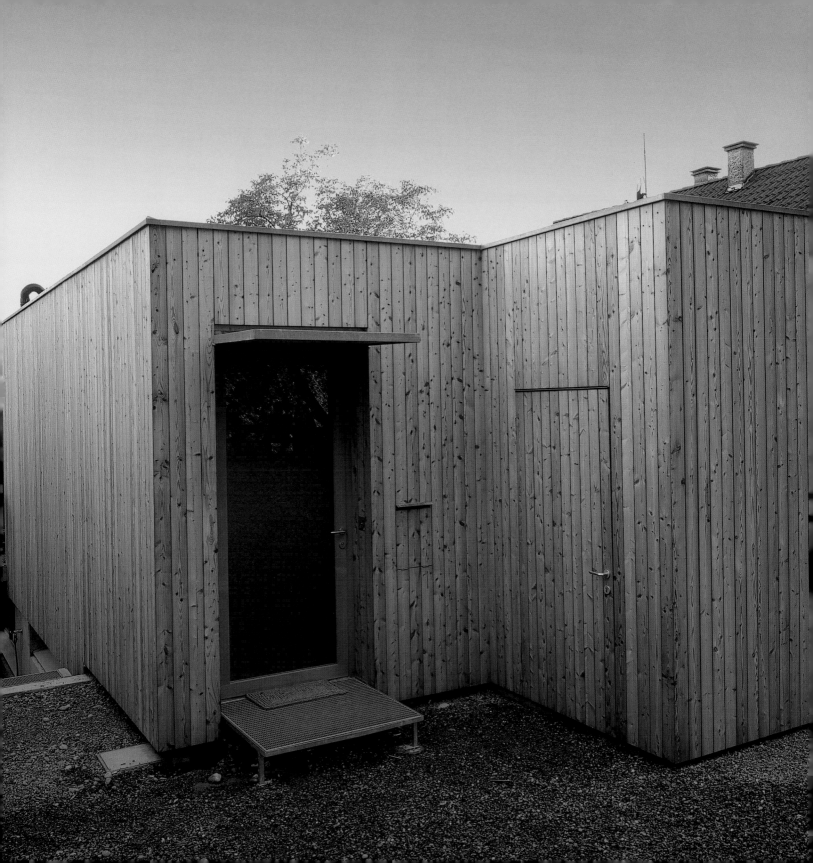

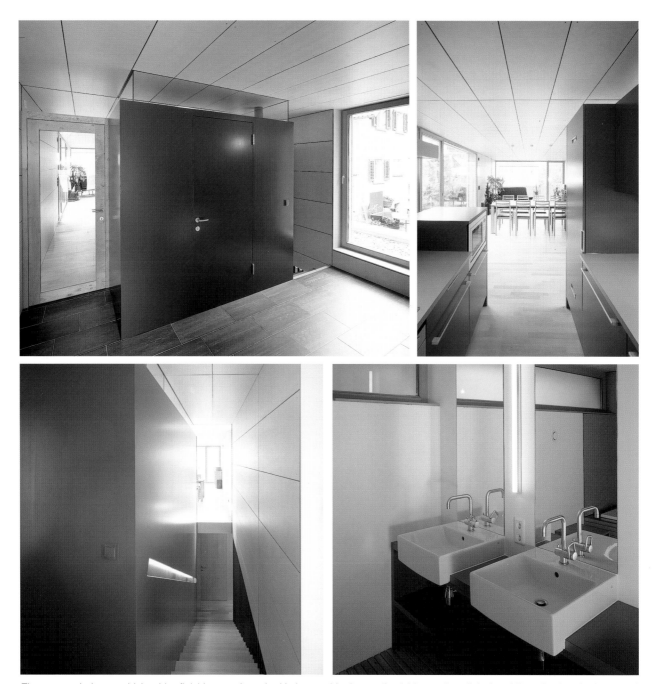

The upper windows, which add a finishing touch to the kitchen and bathroom furnishings, allow light in while softening the impact of these objects on the interior space.

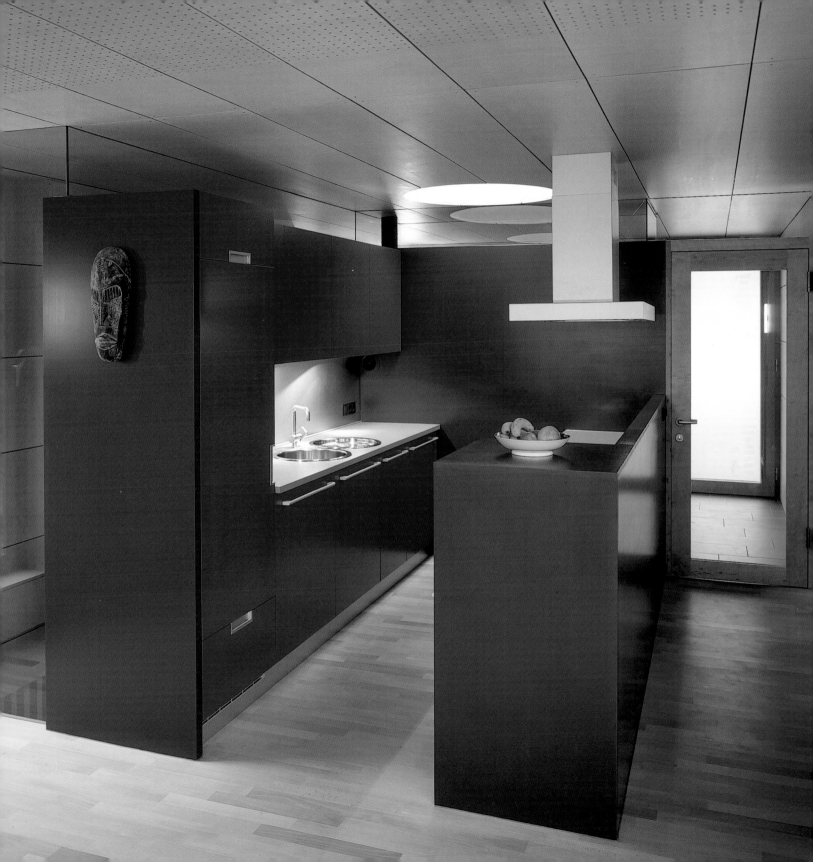

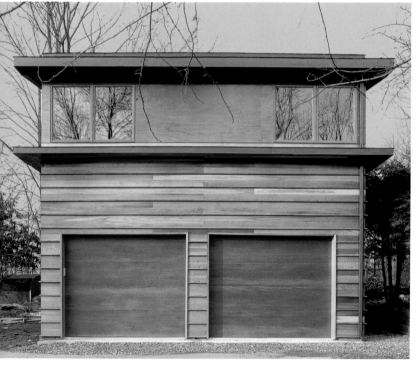

The builder, trained in furniture making, constructed the outer shell of wood as if it were a piece of furniture. This allowed him to get the most out of each piece, based on its dimensions and physical properties, such as grain and color.

Office

BEDFORD, NEW YORK, UNITED STATES 1997 ARCHITECT: DESAI/CHIA STUDIO COLLABORATORS: KATHERINE CHIA, ARJUN DESAI, GREG CLAWSON
PHOTOGRAPHER: © JOSHUA MCHUGH AREA: 1,291 SQ. FEET

A financial consultant requested this small building, set on the rear of his lot, which consists of minimal accommodations where one can work in comfort. It was placed in the middle of an isolated area, densely populated with trees, away from hustle and bustle and the immediate neighbors. These parameters helped determine the design of the project.

The basic plan divides the structure into two floors to avoid taking up too much land and to take advantage of a better position from which to enjoy the surrounding woods. With an area of 1,291 sq. feet, the new building includes parking for two cars, a gym, and a full bathroom on the ground floor. The upper floor is reserved for the main living area, the office, and the library.

The building was conceived as a simple box, integrated with its natural setting. An eave runs, unbroken, around the entire structure, separating the cedar below it from the mahogany plywood above. The cedar is laid out in horizontal strips, creating a thin corrugated façade that gives the house texture and scale. This eave also separates the different spaces: the service areas on the ground floor and the open areas above.

Strips of windows appear on the façade in different patterns, framing different views of the landscape. On the ground floor, windows that emphasize the vertical quality of the landscape look out on the woods, while on the upper floor, light from the north, filtered through the leaves, hits the high windows. These openings create a spacious, linear effect in the work area. In the library, the corner windows and their adjoining vertical shelving frame panoramas of the garden.

DESAI/CHIA STUDIO
House

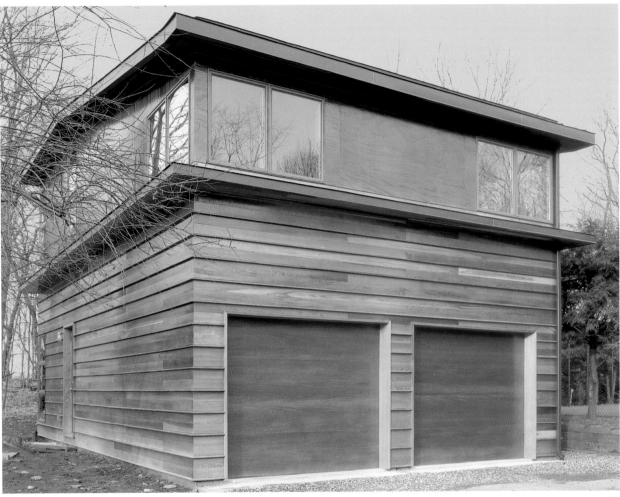

The roof slopes downward toward the front outer wall, making the structure appear lower from the front, and slopes upward toward the rear, creating a dynamic interior space.

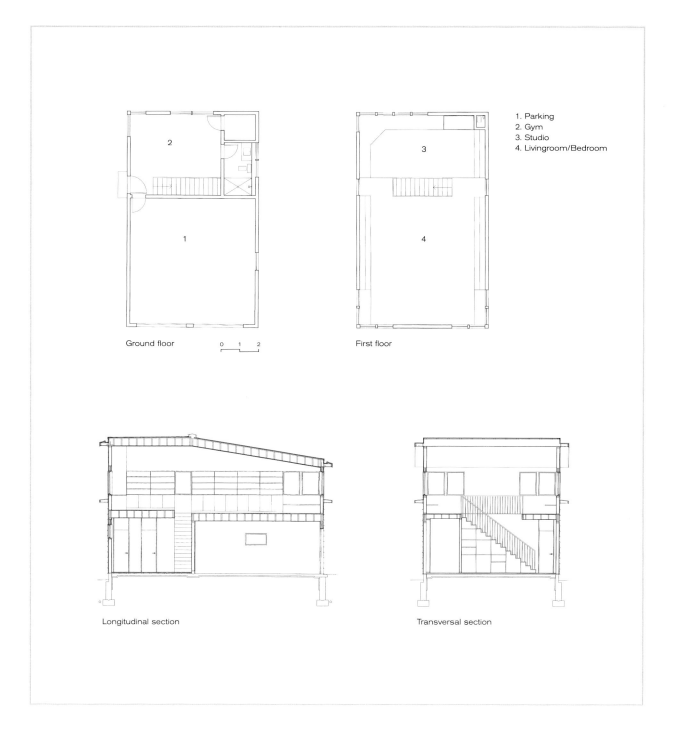

Ground floor

0 1 2

First floor

1. Parking
2. Gym
3. Studio
4. Livingroom/Bedroom

Longitudinal section

Transversal section

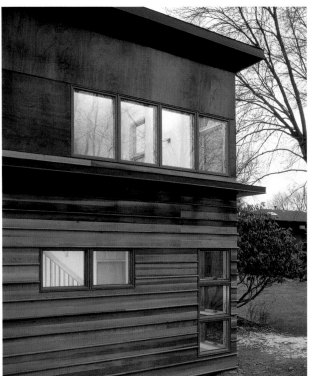
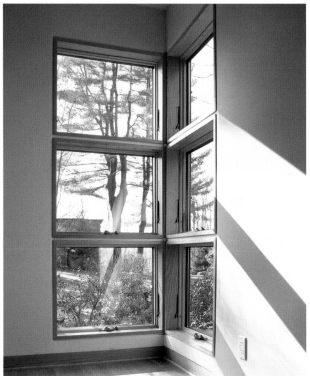

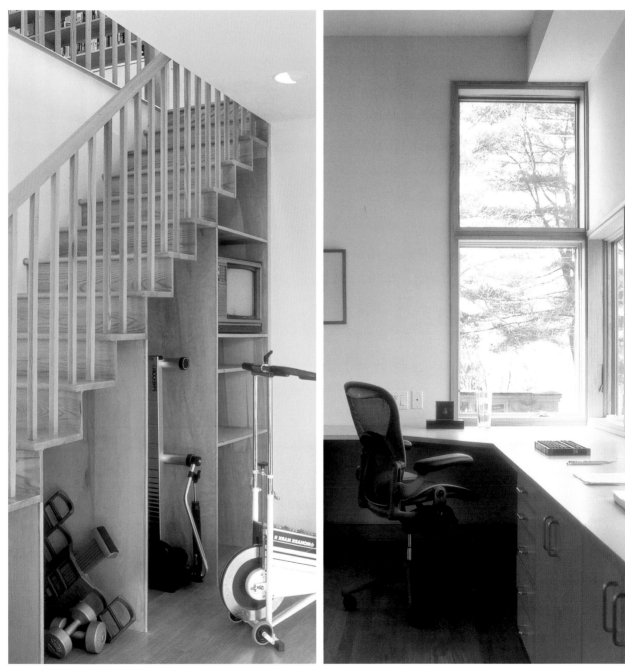

The stairs are all oak, with storage shelves underneath. The other interior details are simple and austere, reinforcing the idea of a quiet refuge in the woods.

The design and construction decisions for this house, located in a small Japanese province, were based on conditions in the neighborhood with its traditional two-story single-family homes made of traditional materials such as brick and wood.

Model Plastic

KANAGAWA, JAPAN 1995 ARCHITECT: MASAO KOIZUMI / C+A PHOTOGRAPHY: © MASAO KOIZUMI AREA: 1,205 SQ. FEET

Houses are located very close together in this high density area. To address this, practically the entire building was constructed out of two types of panels with different levels of permeability. One is a two-faced metal panel covered on the inside with a layer of insulating material. The other is a system of prefabricated panels made-to-order for this project, with the insulation produced by layers of polycarbonate and glass. All the major walls in the house are made of these two elements.

Although each panel costs more than a conventional wall, they are cost-effective because they eliminate the need for complicated anchoring systems and the panels themselves constitute the structural system. The time on-site was cut to three days for the entire framework, the façades, and the interior finish. This resulted in substantial savings on labor and cleanup, and decreased the impact on the surroundings.

The clients wanted the master bedroom to have as much light as possible, but at the same time they were concerned about the lack of privacy, with neighbors in close proximity. To resolve this dilemma, the architect designed a system of bright walls that let light shine through while preserving privacy. The properties of glass for construction purposes were rethought. Generally a material for openings, in this case it was used mainly for the walls, and certain architectural advantages were gained in the process. Glass is very durable and easy to maintain, and entire large prefabricated pieces can be easily obtained.

The two layers of white glass serve as insulation, while the polycarbonate is the structural soul of the panels. This system makes the best use of each material. The bright walls diffuse light and also act as screens on which images or the shadows produced by the residents can be projected.

MASAO KOIZUMI / C+A
Residence

Most of the exterior is covered with a set of panels in three layers: two glass and one polycarbonate.

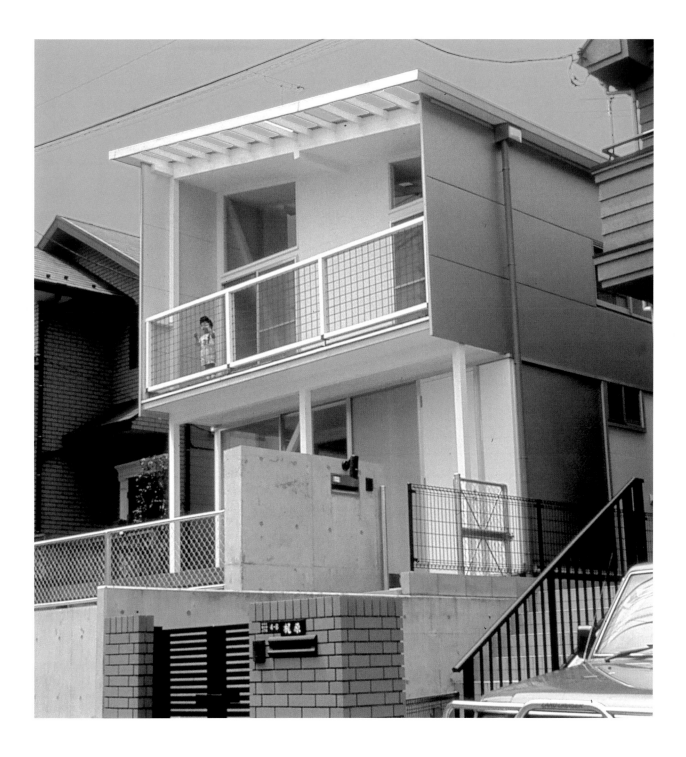

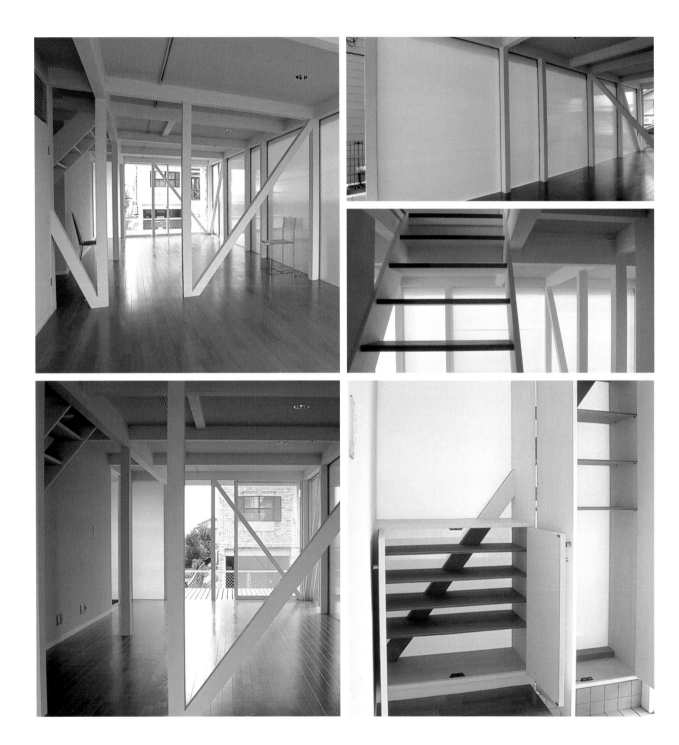

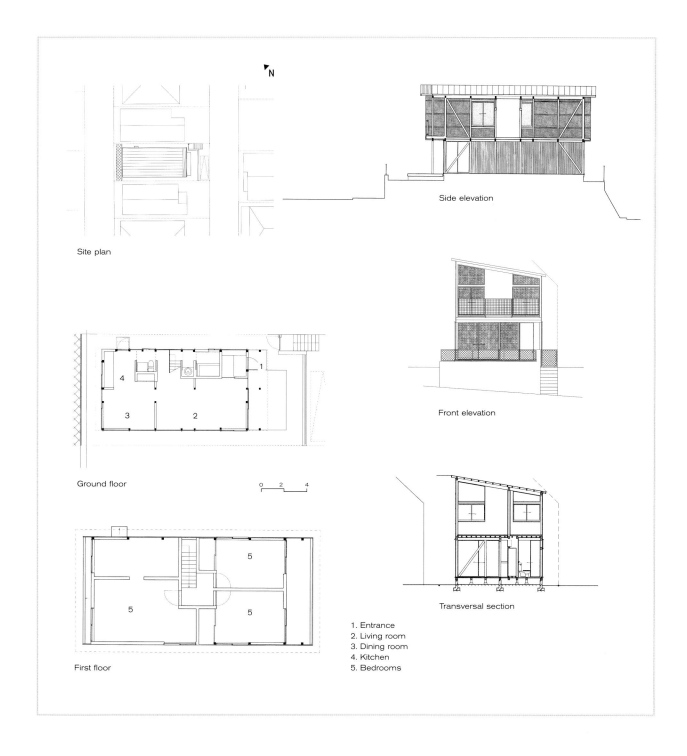

Site plan

Side elevation

Ground floor

Front elevation

First floor

Transversal section

1. Entrance
2. Living room
3. Dining room
4. Kitchen
5. Bedrooms

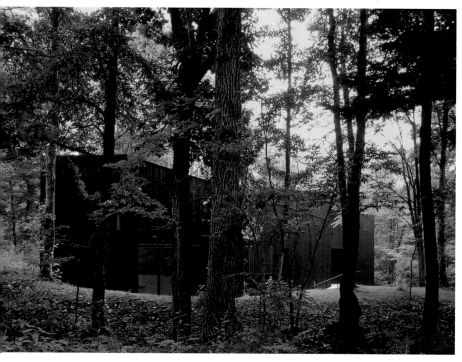

The black paint covering
the exterior creates
a sense of mystery and
blends beautifully with
the colors of the
surrounding forest.
The shape of the roof
reflects the terrain
of the land on which the
building sits.

House on

YAMANASHI PREFECTURE, JAPAN 2000 ARCHITECTO: SATOSHI OKADA COLLABORATORS: LISA TOMIYAMA, EISUKE AIDA PHOTOGRAPHER: © HIROYUKI HIRAI AREA: 1,184 SQ. FEET

This small villa was intended to lodge temporary residents on weekends or for very short periods. At the client's request, a 1,184 sq. feet house was built in the middle of a 8,500 sq. feet parcel, to emphasize and enhance enjoyment of the natural setting. The building rests near the northeastern boundary, with a view of a pleasing panorama of trees, sunrises, and sunsets. The land's undulations create an intimate, natural atmosphere while providing privacy from the only neighboring house to the west.

The house has a diagonal layout which divides it into two gallery-like principal spaces. One of these houses the living area, while the other contains the bedrooms and a bathroom. Its height increases gradually from 41 feet to 57 feet, reflecting the terrain. At the entrance, which is on one end of the diagonal, there is a low, narrow space from which one can see the natural light filtering in toward the living area. Gradually the space expands in height and width as it extends to the brightest part of the house. Moving to the sleeping area on the other side of the diagonal wall is like taking a dramatic step into another setting. This layout and the play of outer openings create a perspective that affords a sensation of spaciousness inside.

In the midst of a dense forest on the northern slope of Mount Fuji in Japan, this plot sits some 15,064 feet above sea level. The terrain, shaped by the lava this volcano once spewed, runs east to west and slopes gently, and the boundaries of this large parcel of land are principally defined by two roads on the northeast and southeast. Another design factor was the location of a grove of magnolia trees.

SATOSHI OKADA
Mount Fuji

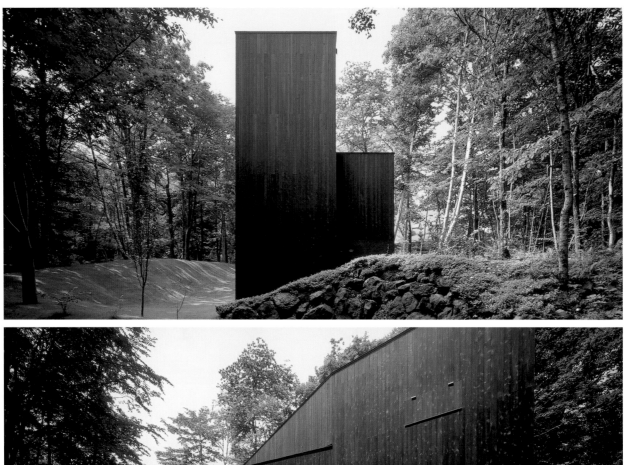

The house has a wooden framework covered with vertical wooden strips. The angles formed by the diagonal wall enhance stability and wind resistance.

Site plan

Ground floor

1. Entrance
2. Living room
3. Dining/kitchen
4. Bedrooms

0 2 4

First floor

Southeast elevation

Northeast elevation

Transversal section

Northwest elevation

Longitudinal section

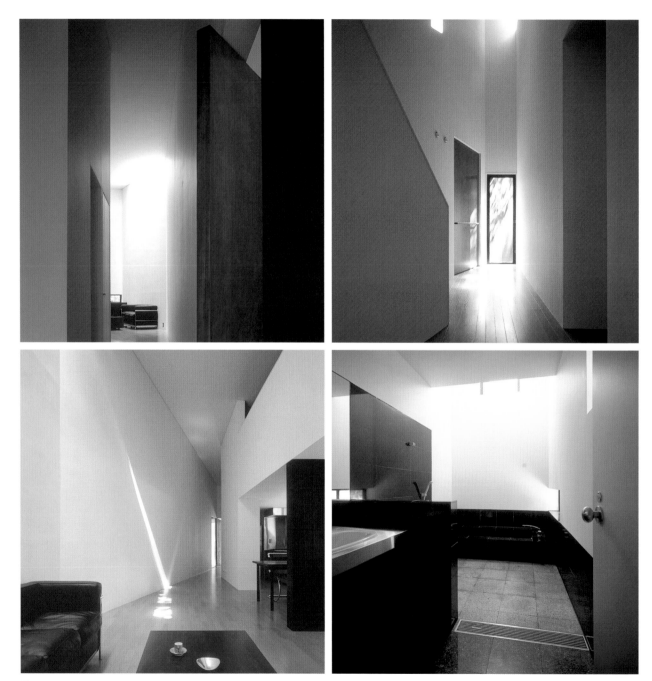

The windows, both in the walls and the roof, were carefully placed to create different effects, expand or reduce the space, frame panoramic views, and bring the outside in.

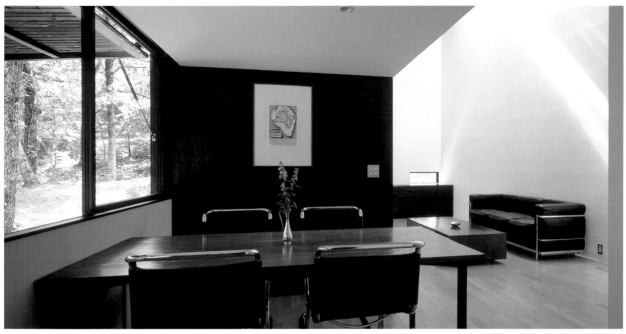

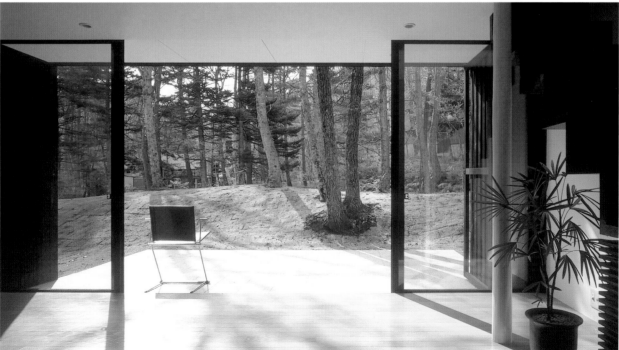

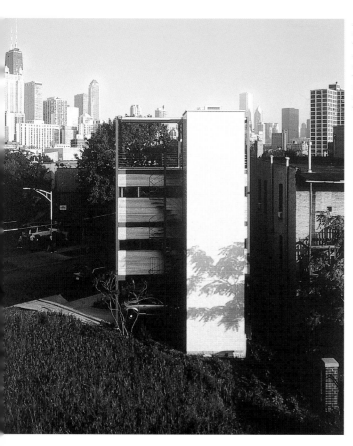

A simple structure, consisting of two basic, tall units, takes maximum advantage of this plot's difficult conditions. The vertical design also makes it possible to enjoy splendid panoramas of the city.

Tower

CHICAGO, UNITED STATES 2001 ARCHITECT: FREDERICK PHILLIPS COLLABORATORS: VINCENT RIGG, KEVIN ADKINS, CASMIR KUJAWA PHOTOGRAPHER: © WILLIAM KILDOW AREA: 1,141 SQ. FEET

In Chicago's Cabrini Green section, on a small triangular plot considered impossible to build on, this 1,141 sq. feet house has two principal components. The main structure is an open four-story iron unit occupying 344 sq. feet of the lot. The other unit is an adjoining 129 feet-high box of concrete that connects the different levels of the metal structure.

Since the plan was based on a vertical composition, the house is divided into floors according to use and traffic flow. The ground floor and top floor are completely open, serving as a carport and terrace respectively, while the middle two floors, where all the other activities take place, are closed. Since on the higher floors, the views of Chicago are better, the social area was placed on the third floor, which contains the kitchen, dining room, and living room, and offers easier access to the terrace. From there one can enjoy a 360° panorama of the city. On the more private second floor are two bedrooms and a bathroom.

The details and finishes emphasize the project's small scale. This is why the metal framework has been left open to view, minimizing the profiles and making maximum use of the available space. On the terrace, retractable awnings provide protection from the sun's rays, while the windowless vertical surfaces are covered with corrugated sheet metal that helps insulate the interior.

FREDERICK PHILLIPS
House

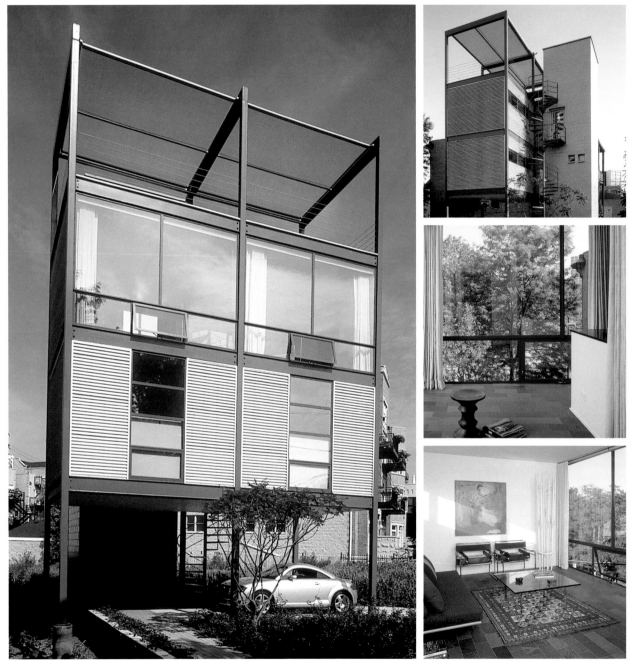

The interior reflects the same simplicity with which the general composition of the building was conceived. Unobstructed, continuous, uniform spaces in which the functions are grouped enjoy ample openings to the outside.

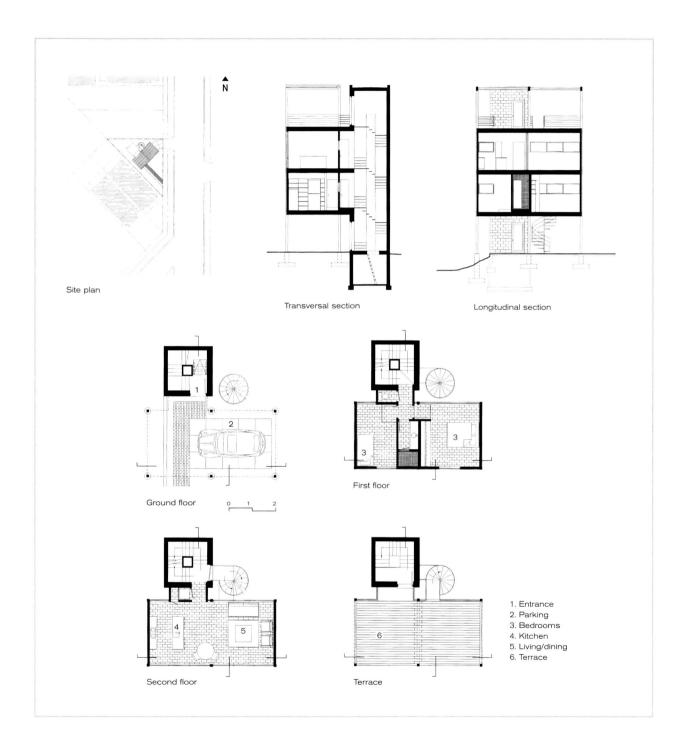

Site plan

Transversal section

Longitudinal section

N

Ground floor

0 1 2

First floor

Second floor

Terrace

1. Entrance
2. Parking
3. Bedrooms
4. Kitchen
5. Living/dining
6. Terrace

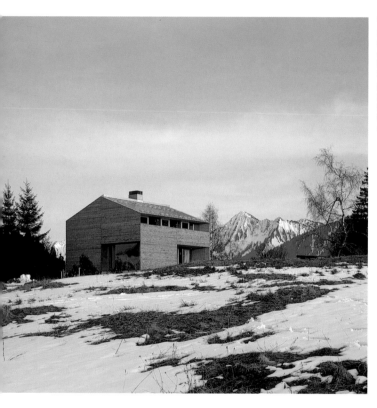

The house's monolithic appearance, which is the result of a technical solution and the search for a contemporary language, solves the problems related to its placement while blending with the austere look of the neighboring structures.

Vacation

Furx, Austria 2001 Architect: Marte.Marte Architekten Collaborators: René Bechter, Davide Paruta, Alexandra Fink, Stefan Baur

Photographer: © Ignacio Martínez Area: 1,130 sq. feet

What at first blush seems to be a closed, modest structure, very similar to the neighboring houses in this Austrian province, is really an exercise in design, the principal theme of which is the arrangement of the exterior openings. The house is at the end of a minor road, generally used only by hikers, which branches off the main highway that runs through the Rhine Valley. Since the plot is located on a mountain top, the designers took advantage of the views while integrating the building with the architecture typical of small houses in the region.

The house's four principal glass surfaces produce four sections of images, which describe the architects as four lenses with different exposure mechanisms. These mechanisms are elements that slide along the entire height of the window and can completely close the house, rolls of fabric that filter the light, or the system of retractable frames that make it possible to open up the whole house to the exterior.

Inside this plain, austere unit, the layout is based on a cross, with four spaces that are open and connected to each other. Each room has a closed surface and a window which, since the position of the glass can be changed, creates an effect of depth from both the inside and the outside. This effect, on all four sides, gives the building a solid, magical appearance.

The use of materials and the handling of the technical details and interior finishes are based on a homogenous and meticulous design. A concrete central fireplace contrasts with the matte larch veneer that covers most of the surfaces. The construction details include the integration of concrete, glass, and wood to achieve a monolithic appearance.

Marte.Marte Architekten
Home in Furx

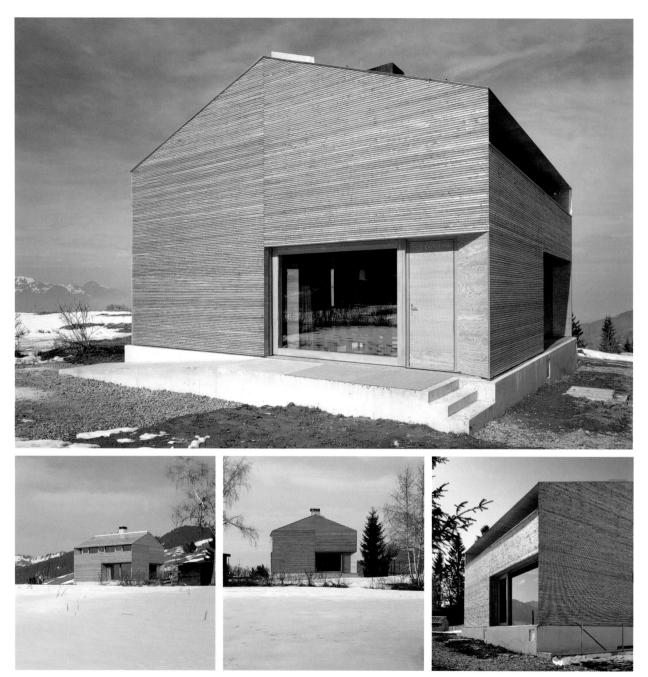

The house, for the most part a structure made of prefabricated elements, is supported on a concrete base that serves as a foundation while keeping it off the ground.

Site plan

2

3

1

4

Ground floor 0 2 4

5 5

5

First plan

1. Living room
2. Studio
3. Dining
4. Kitchen
5. Bedrooms

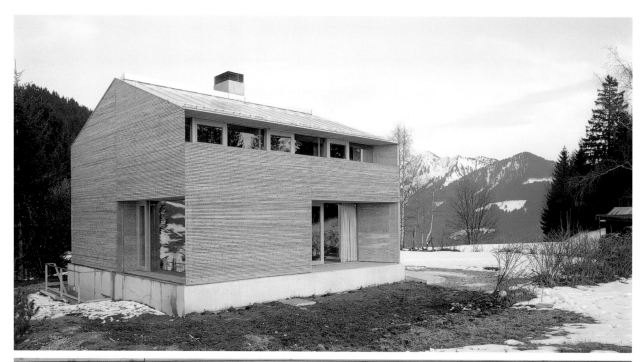

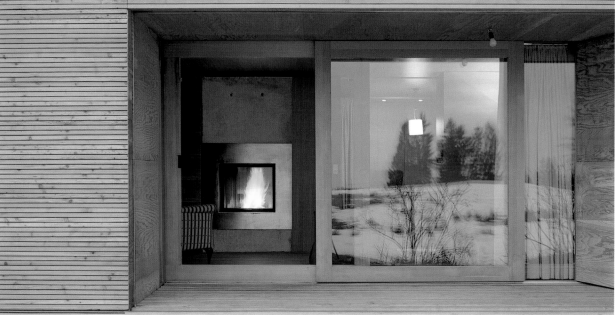

The retractable windows accentuate the solid appearance while creating exterior terraces that accentuate the relationship between the interior and exterior.

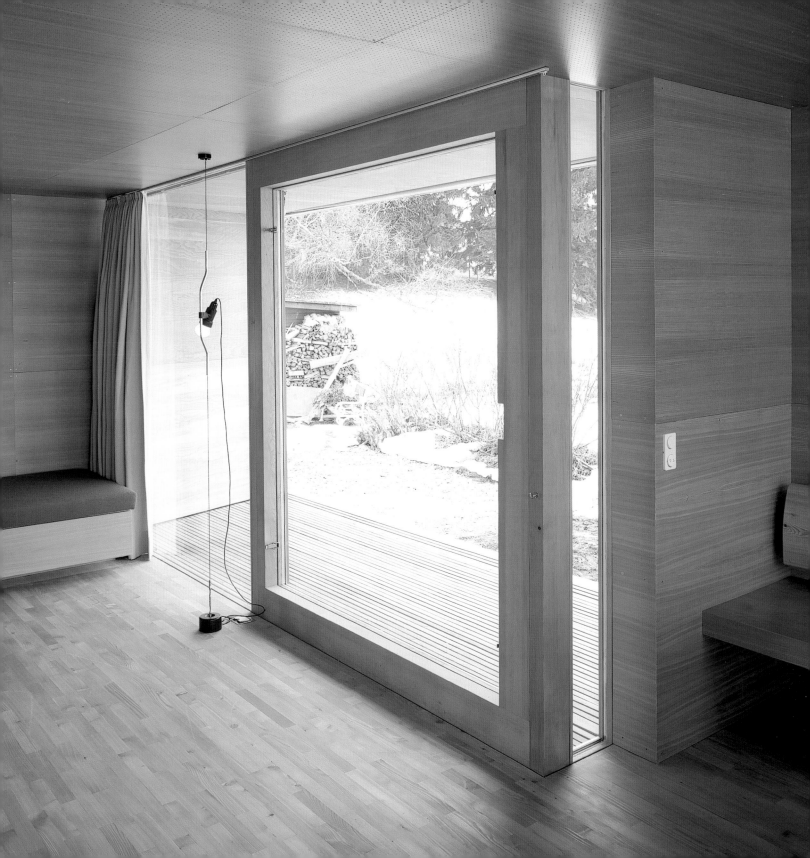

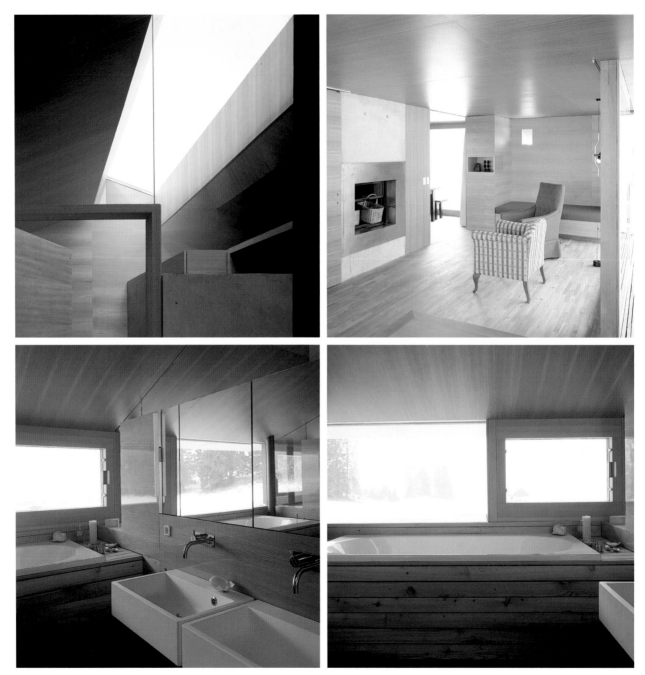

While larch wood is used outside in slender horizontal strips, a larch plywood was used inside to form more continuous and uniform surfaces.

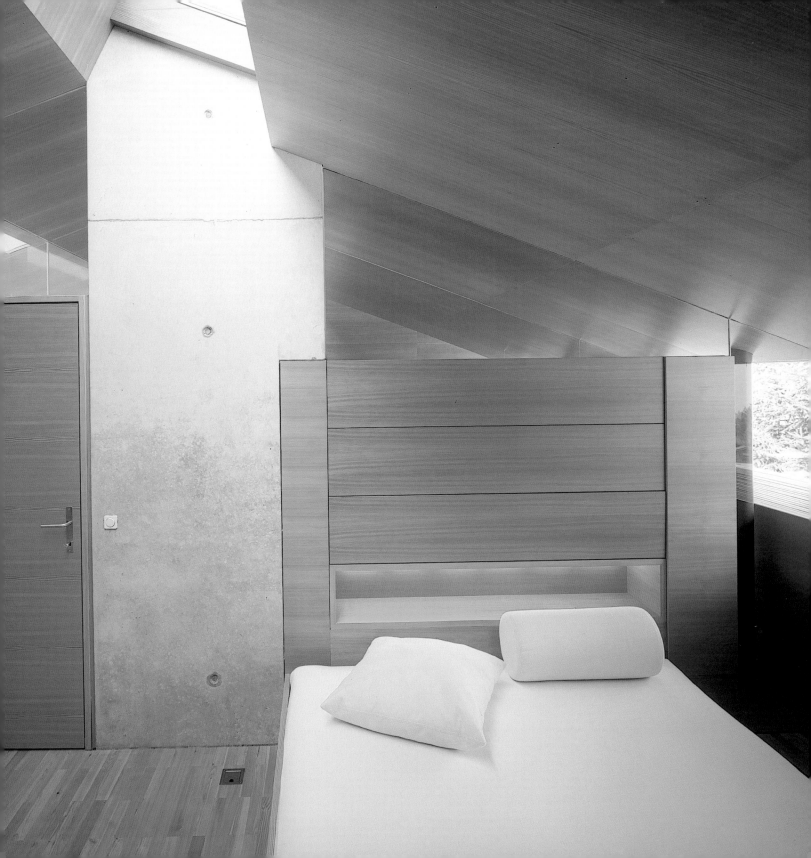

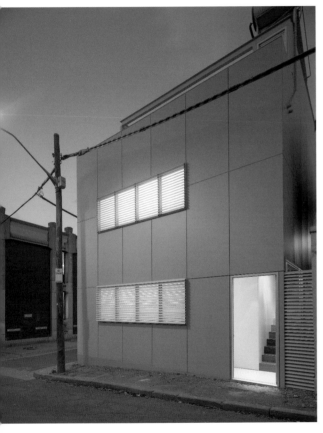

Simple shapes and materials have produced a strong image that blends with the industrial and commercial buildings in the area, but still retains a subtle refinement, thanks to the thin aluminum panels that cover the building's entire outer surface.

Dodds

SURRY HILLS, AUSTRALIA 2001 ARCHITECT: ENGELEN MOORE COLLABORATORS: WILL FUNG, SEAN RADFORD, ANGELA GABB PHOTOGRAPHER: © ROSS HONEYSETT AREA: 1,076 SQ. FEET

The plot is located in the suburbs of Sydney and was suitable for a small house that would fit in with the multiple uses in the sector. This neighborhood is a mix of residential complexes, industrial buildings, and the headquarters of a popular international publication. The building is at the end of a row of Victorian houses, a position generally used for commercial space.

All of the house's dimensions are determined by the standard measurements of the panels that cover the entire surface, except for the windows and doors. The unified, solid look was reinforced by painting all the exterior elements the same silver color, thus giving all the materials the same finish.

The interior is quite the opposite; the layout is almost completely open. A two-story living room – which includes a small sleeping loft – provides a sense of transparency and spaciousness. The space extends even farther, through the sliding glass doors that open onto an interior patio on the north side. Other doors, at right angles to the sliding doors, open to the east, where a long pool separates the house from the original shared wall, in which the original brick can still be seen.

The two levels are connected by sheet metal stairs supported by a continuous yellow block. On the ground floor, unit contains the laundry and pantry, while on the upper floor it serves as a storage closet. The only closed unit in the house is the bathroom, which resembles a sealed box lined inside and out with aluminum panels. Behind the storage closet, the stairs continue up to a roof terrace that offers scenic views of the area.

ENGELEN MOORE
House

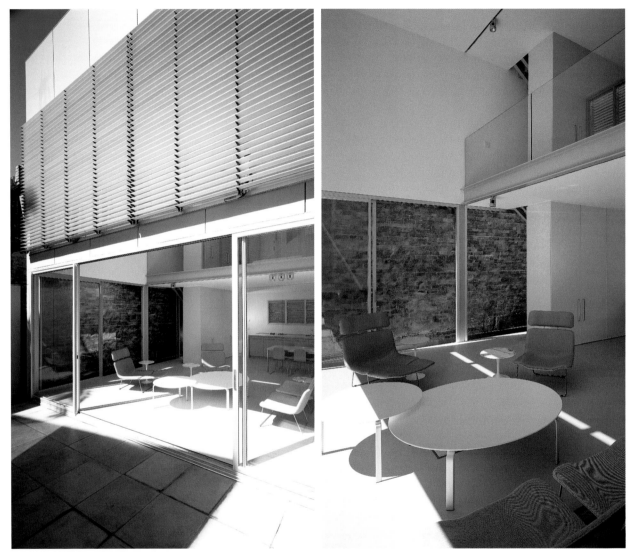

The pool alongside the house is part of the air-conditioning system and emphasizes the contrast between the Victorian brick and the contemporary materials of the new structure.

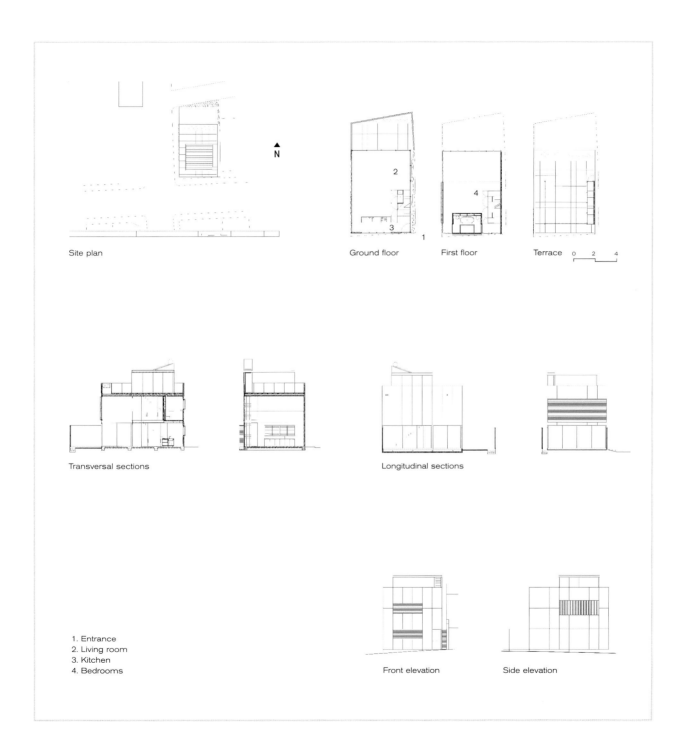

Site plan

Ground floor First floor Terrace 0 2 4

N

Transversal sections Longitudinal sections

1. Entrance
2. Living room
3. Kitchen
4. Bedrooms

Front elevation Side elevation

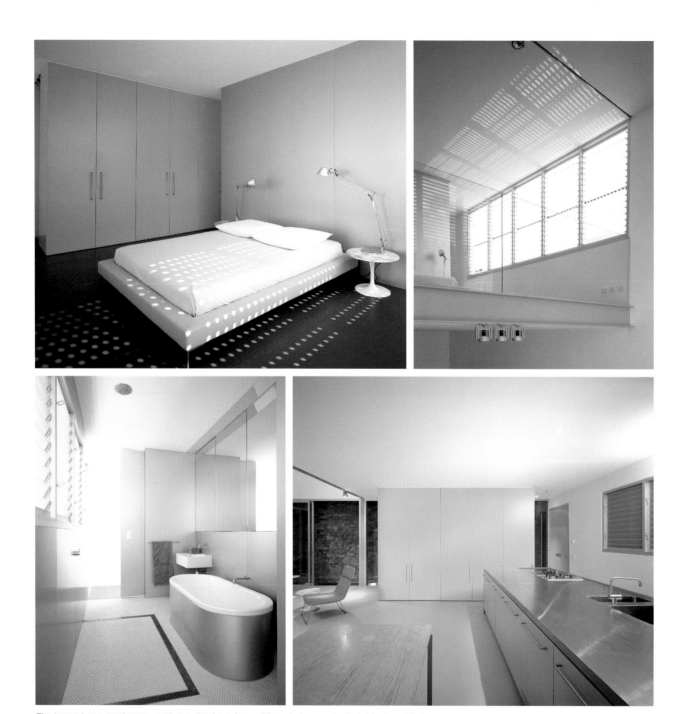

The house has natural cross-ventilation, thanks to large sliding windows and adjustable glass blinds.

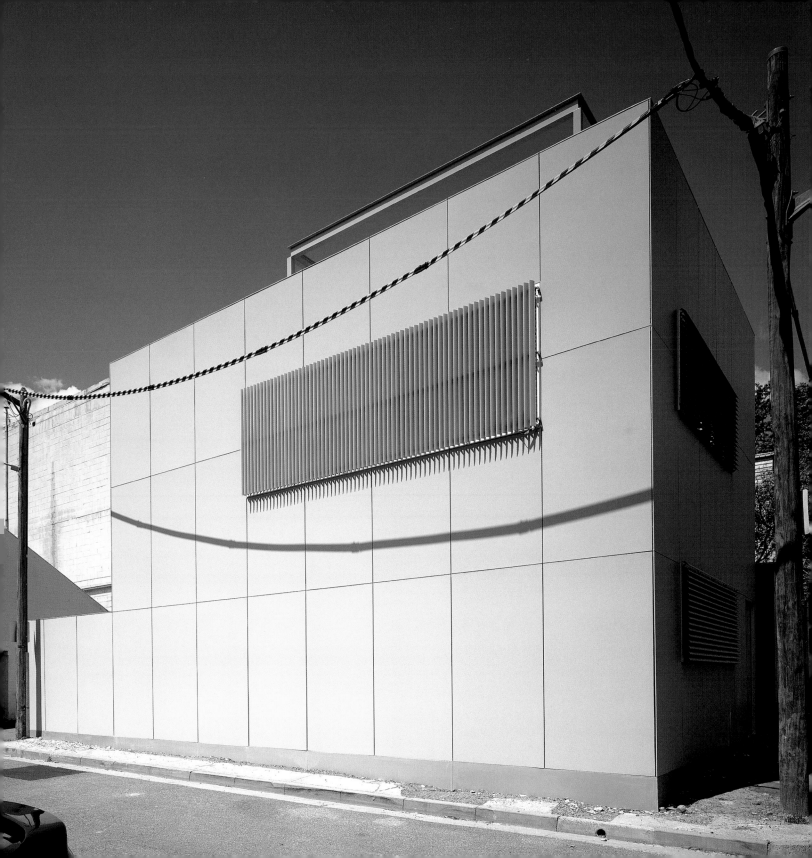

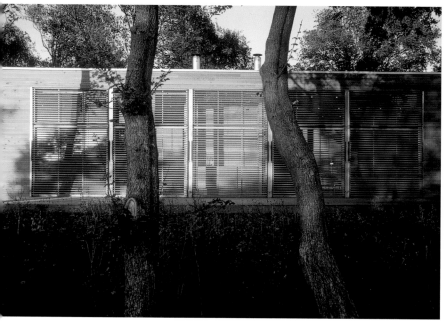

The dual use of
this house as a summer
residence and work
space for artists in
search of a peaceful
setting was the starting
point for this project.

Summer Residence

VEJBY STRAND, DENMARK 2000 ARCHITECT: HENNING LARSENS TEGNESTUE COLLABORATORS: PEER TEGLGAARD JEPPESEN, ANDERS PARK, CLAUS SIMONSEN
PHOTOGRAPHER: © JENS LINDHE AREA: 1076 SQ. FEET

The unique plan, combining a living space, gallery, and work space for artists, needed a specific setting, natural but still accessible in order to meet the client's requirements. The plot that was chosen is surrounded by a forest of birch trees in northern Zealand, the same island on which Copenhagen is located, 592 feet above sea level – a very unusual landscape for a Scandinavian country such as Denmark.

The building, which could not exceed 1,076 sq. feet in size, had to serve as a work and leisure space for several artists. The plan is symmetrical, with two principal spaces, one for work and one for rest, at either end of the building. These are joined by a service module in the center of the building. Here the bathroom, the kitchen, and two fireplaces are clustered. Sliding doors built into the partitions define these spaces and can divide the rooms or join them into a single, continuous space that extends outside to wooden decks.

The house was configured to resemble a long wooden box in which just one of the ends, the one that faces south, is totally open, due to an enormous window. The western side is closed by wooden shutters. When the house is occupied, they can be fully or partially opened, like blinds, to control the entry of light.

The structure consists of metal frames covered with wooden slats, and a central unit of brick, in which the service areas are located and which gives the system some rigidity. Panels of birch plywood were used to finish the interior surfaces, while larch – which, over the years will acquire a fine, silver-gray patina – was used on the outside. In this way, the building blends in with the natural colors surrounding it.

HENNING LARSENS TEGNESTUE

and Gallery

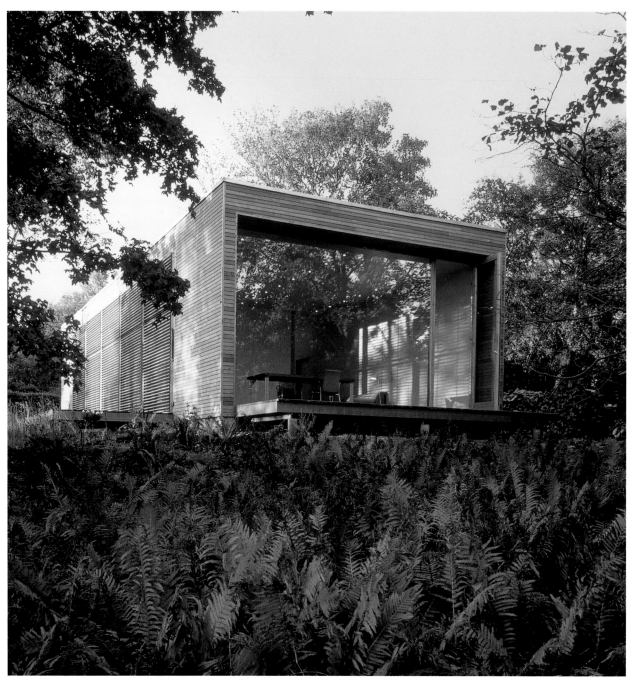

The wooden decks enhance the image of the house as an object floating above the dense growth of ferns covering the site.

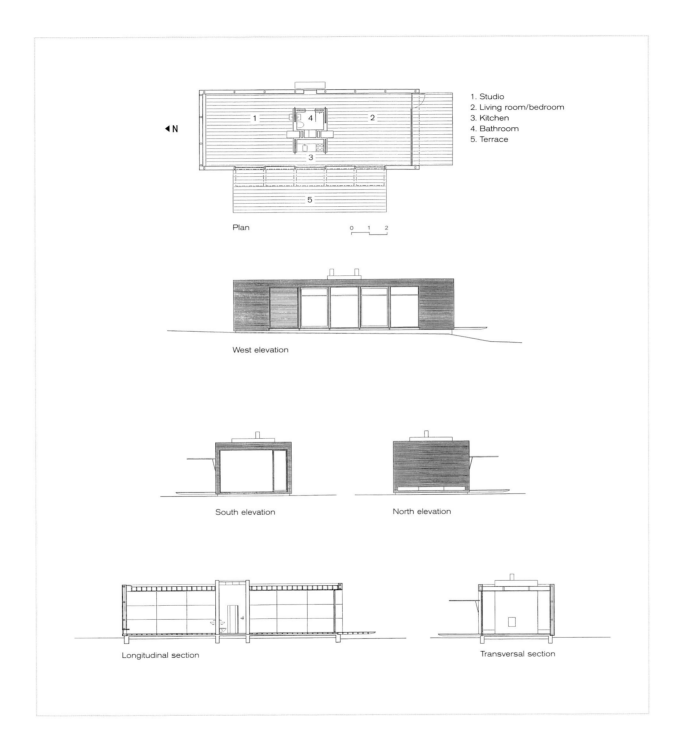

◀ N

1. Studio
2. Living room/bedroom
3. Kitchen
4. Bathroom
5. Terrace

Plan 0 1 2

West elevation

South elevation North elevation

Longitudinal section Transversal section

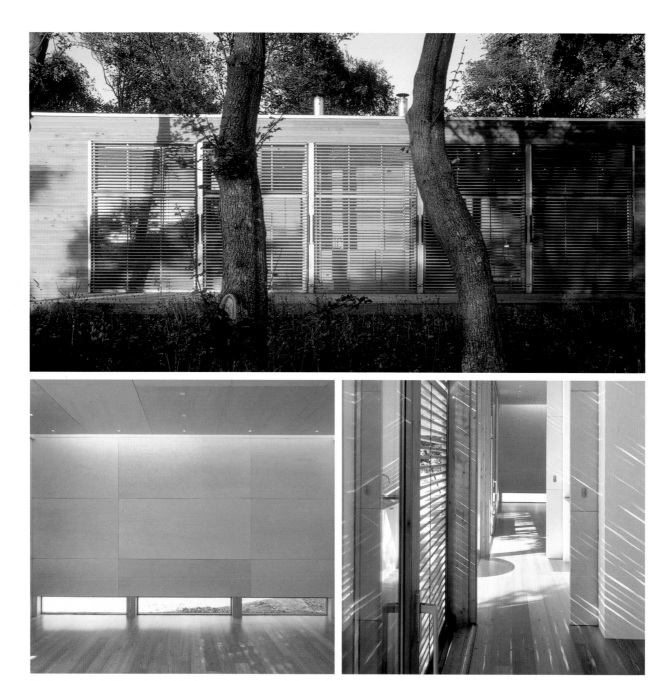

The basic concept of the project and its elemental geometry made it possible to use traditional wood construction techniques. The openings are carefully designed to provide adequate lighting, according to need, or to highlight certain aspects of the setting.

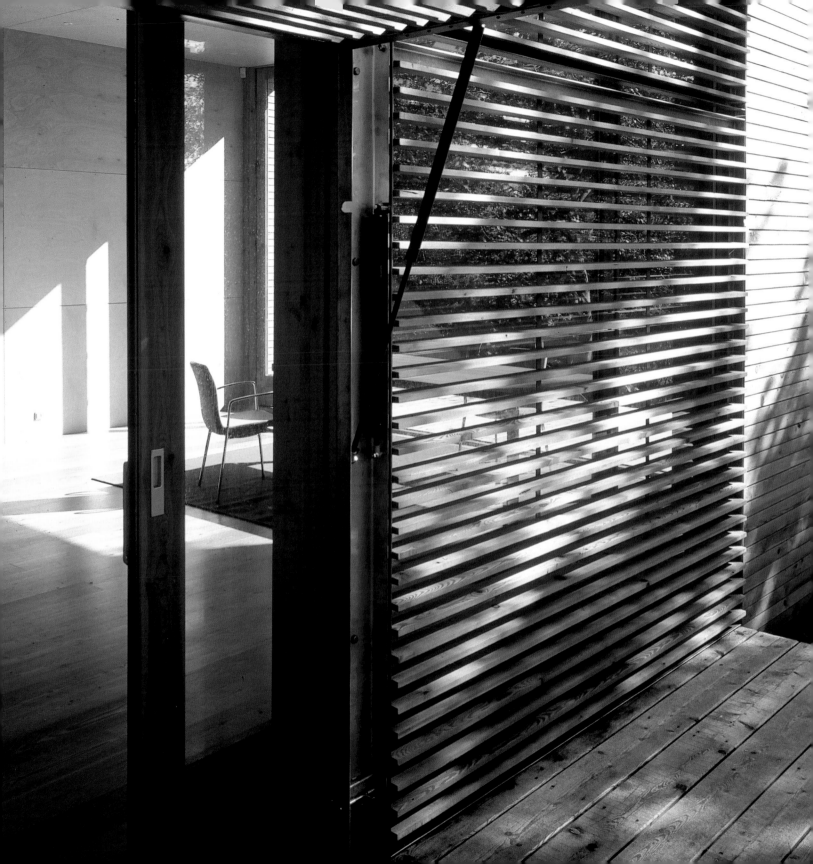

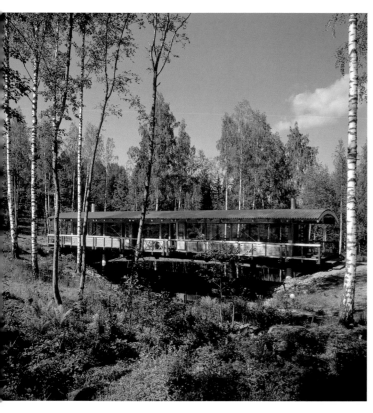

Placing the house like
a bridge over the river that
crosses the land took
advantage of both banks
while minimizing the
impact on the terrain.
The water is controlled
to create a nearby
landscape and integrate
the riverbed into the house.

Soivio

VAMMALA, FINLAND 1998 ARCHITECT: **JUKKA SIREN** COLLABORATOR: **ARTO HUJANEN** PHOTOGRAPHERS: © **LARS HALLÉN, ARNO DE LA CAPELLE** AREA: **1,022 SQ. FEET**

The name and layout of this project result from the marriage of the architect's and the clients' ideas. The architect greatly admired a small Roman bridge in Spain, and the clients insisted that both banks of the river that runs across the property were ideal sites. A highly original plan for a weekend house, with both banks of the river joined by a single building, is the result.

This plot sits in a dense pine forest crossed by a small river that flows to the Baltic Sea. The project started with a minor alteration to the landscape, the creation of a 22 feet-deep reservoir for river water. It serves as a spot for salmon fishing and a natural swimming pool for the house, creating the impression that the house is a boat, gliding smoothly and continuously along the river.

While the plan is highly unusual, especially for this region, the design is practical in its layout and use of land. The house rests on a long wooden platform that allows contact with the outdoors in every direction. On the platform is a long unit in which the rooms succeed each other. Any of the interior spaces can be reached from the terrace, so each space is independent, yet integrated into a single interior space.

The construction process was simple and economical, based on materials that were easy to obtain in the region, along with an efficient system. The wood comes from the site, where it was cut and pre-treated. For the terraces, the wood was pressure treated, and each plank was heat treated. To make the platform long enough to reach across the river, it was reinforced with metal parts and cables.

JUKKA SIREN
Bridge

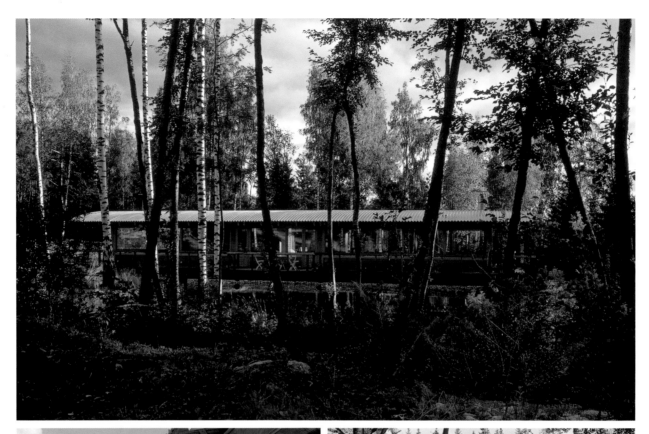

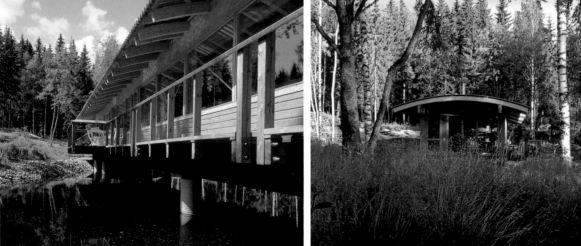

The curved roof is constructed of pieces of laminated wood that support a light zinc sheet, visible from the exterior.

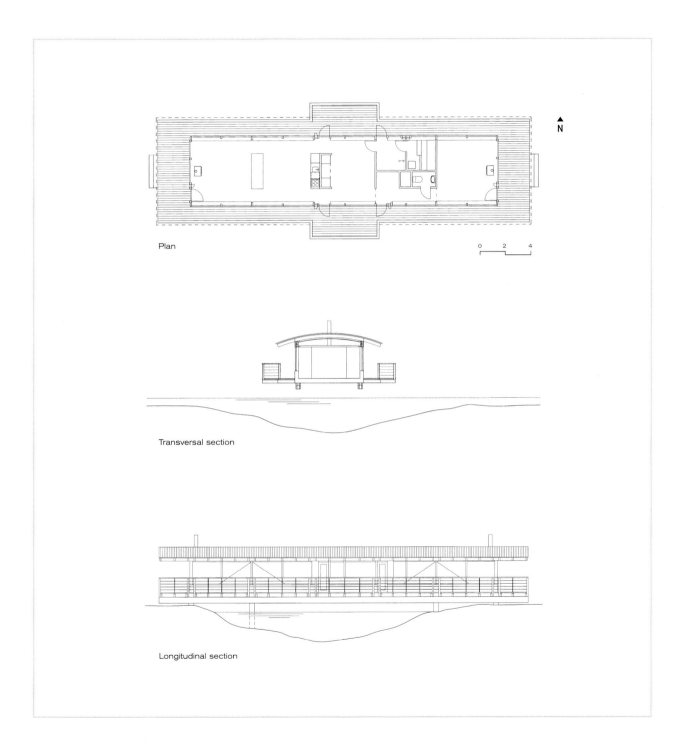

Plan

N

0 2 4

Transversal section

Longitudinal section

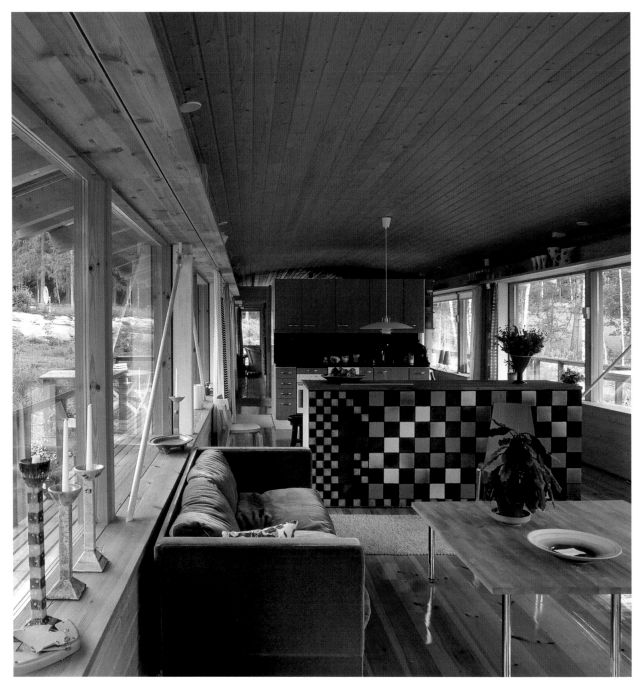

Inside, the entire length of the house is open, allowing for total integration with the terrace and the exterior landscape.

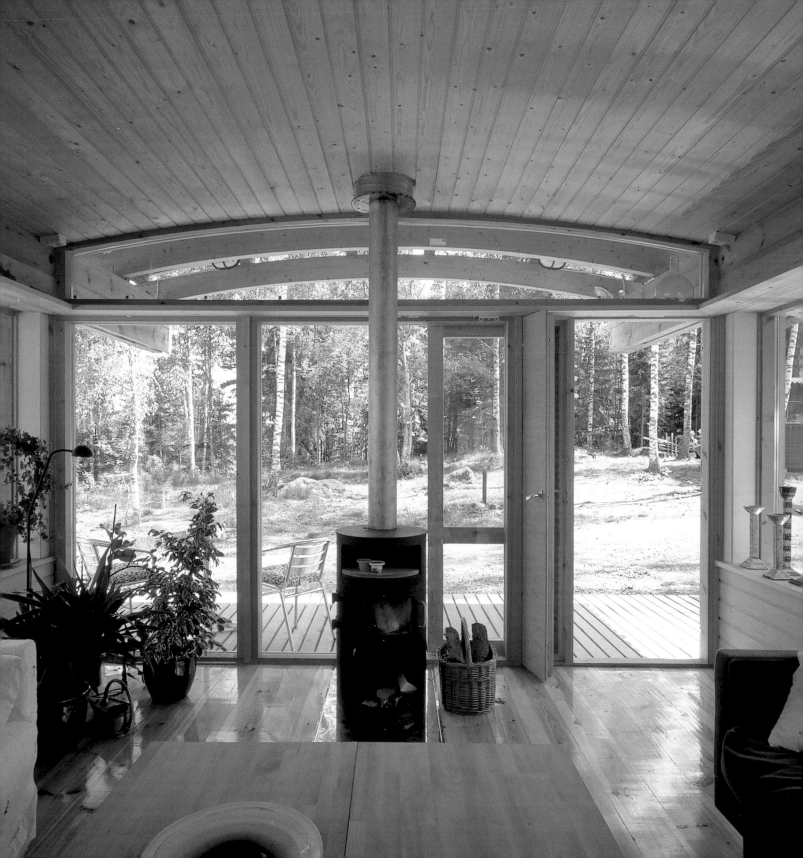

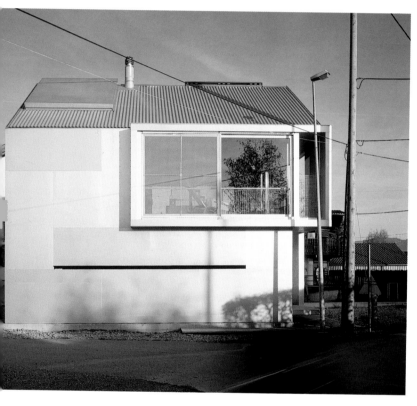

A range of housing styles, such as covered cubes, long cabins, rustic 1930s houses, and small tent-like retreats, served as reference points in the process of designing this house.

Steinhauser

Fussach, Austria 2000 Architect: **Marte.Marte Architekten** Collaborators: **Robert Zimmermann, René Bechter, Davide Paruta, Alexandra Fink, Stefan Baur**
Photographer: © **Ignacio Martínez** Area: **915 sq. feet**

The special nature of this house's design originated in the client's basic coordinate requirements: the dwelling had to harmonize with the dock on the banks of a navigable canal. The clear reference to boat building inspired the architects to create a compact structure of aluminum panels with precise, controlled outer openings. Resting on the edge of a canal, the building blends with the neighboring houses.

Two large openings on the northern and southern sides – that is, on either side of the living room – break up the metal exterior finish and create a feeling of spaciousness. A rolling door, also metal, hides the access to the dock area on the ground level. Here, taking advantage of the space under the stairs, is a small storage area, visible on the exterior as slender grooves in the aluminum panels.

Inside, the lightweight materials chosen allowed for rapid construction of a space that radiates warmth. Dark red concrete panels cover the floor in the kitchen, and the same color is used for the kitchen furniture and in the central area where the fireplace is located. The bathroom and bedrooms are laid out in a row coming off a corridor in the western part of the house. Hallways traverse the entire space rather than concentrating at one point.

A long, narrow slit on the western side includes a device that swings out to provide ventilation for the bedrooms. A small loft is accesed by metal stairs that unfold at the push of a button. These features, as well as the roof that opens up via a hydraulic system, reinforce the references to nautical engineering.

Marte.Marte Architekten
House

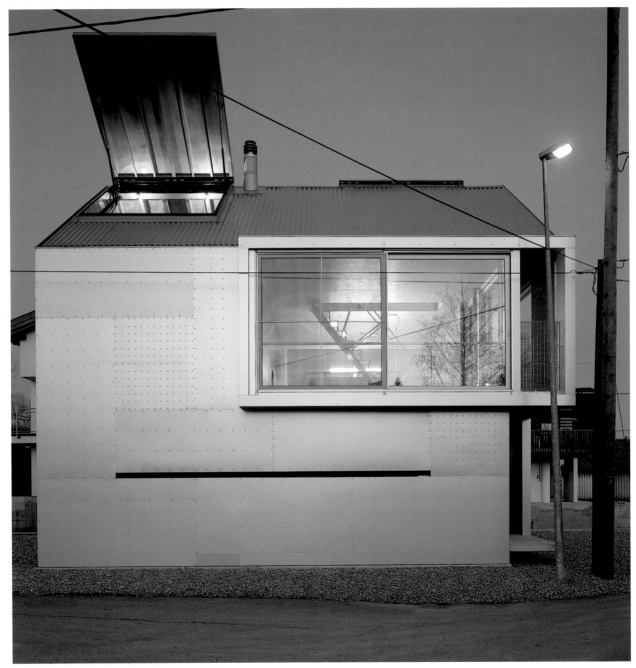

The upper space, under the roof, is used as a solarium, due to the fact that part of the roof opens up. From here, one can enjoy a panoramic view of the entire area, including the lake.

1. Dock
2. Pedestrian access
3. Living room
4. Dining/kitchen
5. Bedrooms

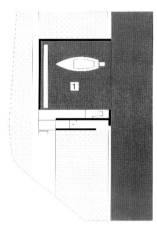

Basement plan

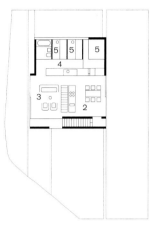

Ground floor

0 2 4

Site plan

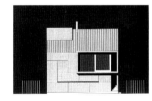

West elevation

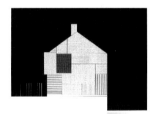

South elevation

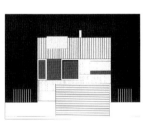

East elevation

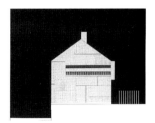

North elevation

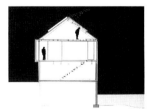

Section

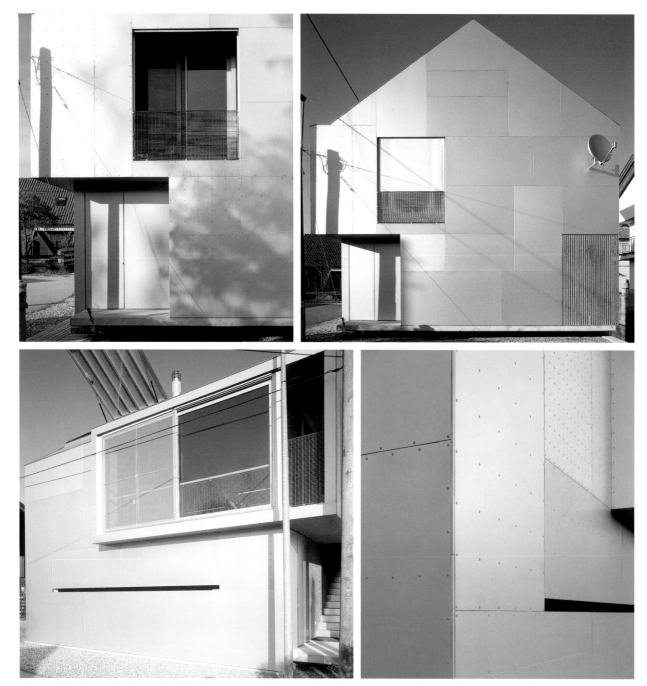

The simplicity of the building is enriched with the fine texture of the rivets in the aluminum panels and the powerful arrangement of the openings.

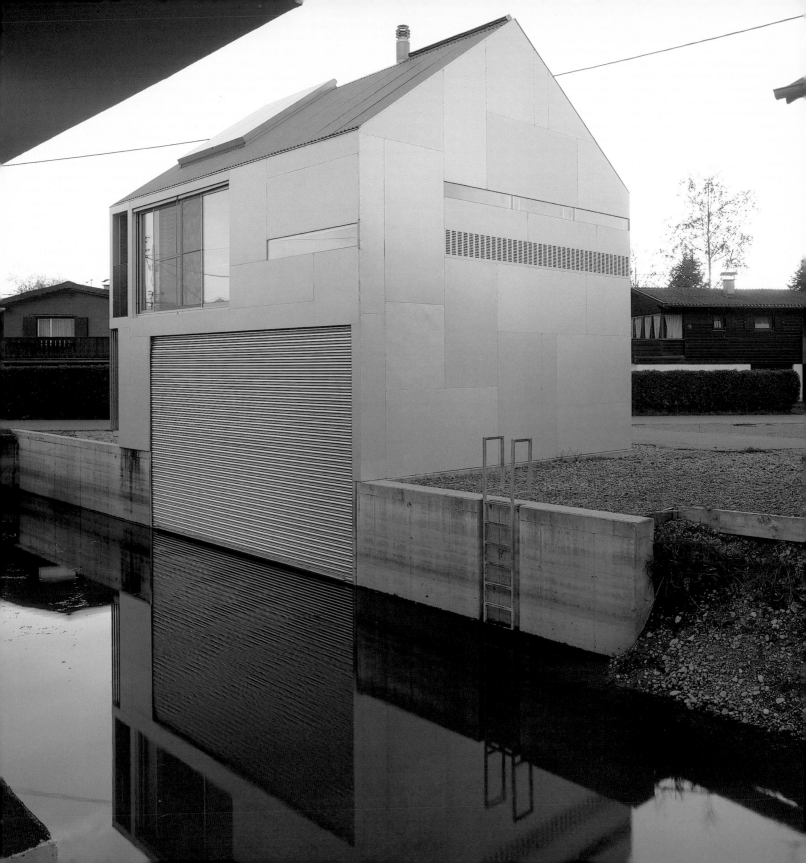

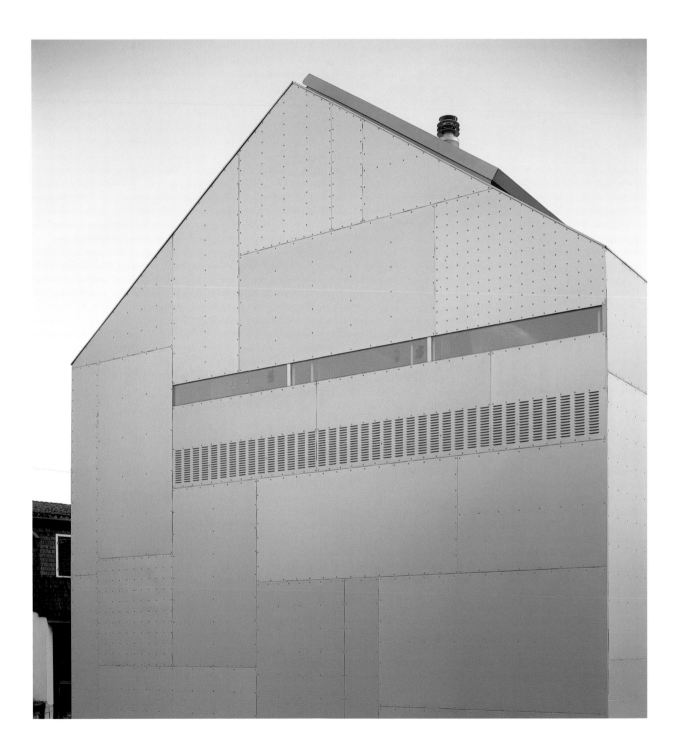

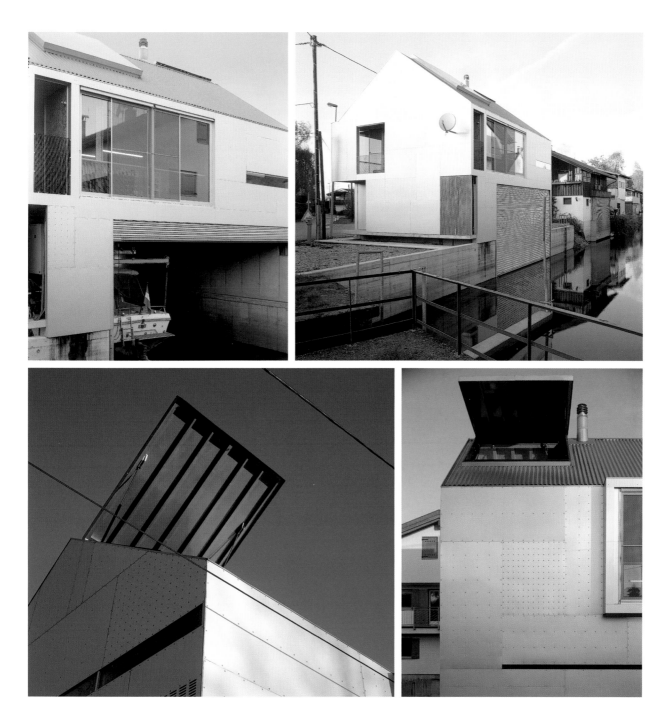

Despite the materials and the contemporary appearance, the house is fully integrated with its surroundings.

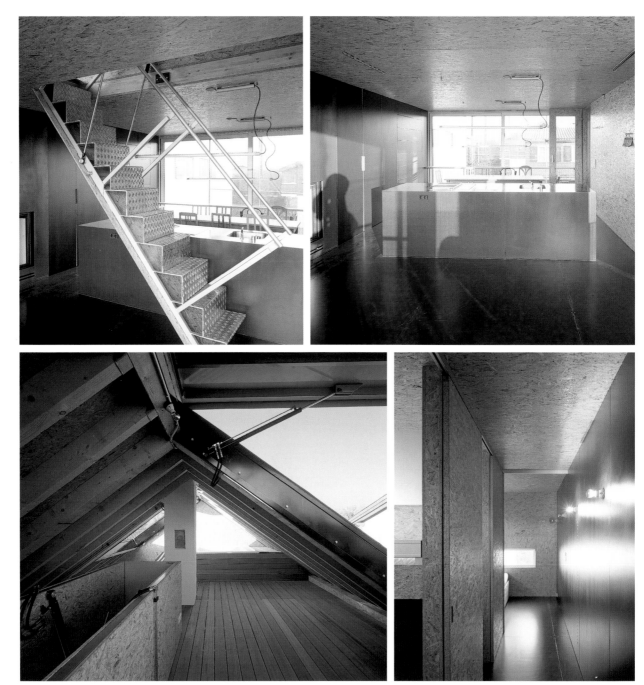

Materials such as plywood and wood chipboard were used inside to give the space a warm atmosphere.

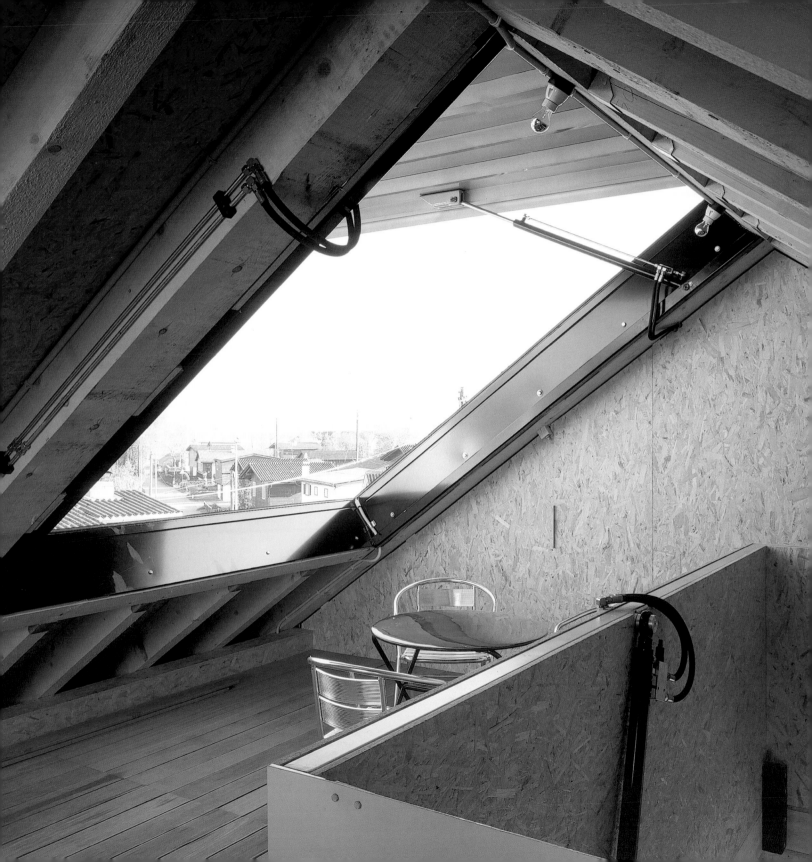

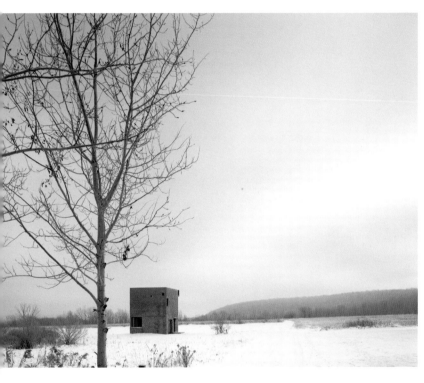

The building was conceived with a basic, uniform, solid shape to create a small residence in which the vast landscape is the protagonist.

Ithaca

Ithaca, New York, United States 2000 Architect: Simon Ungers Collaborator: Mathias Altwicker Photographer: © Eduard Hueber / Archphoto Area: 893 sq. feet

The conceptual jumping off point for this project was the desire to create a monolithic, sculpture-like structure in the midst of this vast upstate New York landscape. The 345-acre site is on a flat, wide-open stretch of land. Bands of colors in the ground, the dense woods, the mountains, and the sky dominate the scenery in all directions.

To take the best advantage of the views of a nearby ravine and the woods that cover a third of the property, the house was situated at the edge of the lot.

A future unit, separate from and smaller than the current one, with just one level, will complete the grouping and include a patio linking the two structures.

The home, used as a getaway for short periods or on weekends, is divided into two levels. On the ground floor of this cube-like structure is a parking area and a small office, while the upper floor houses the kitchen, bathroom, living room, and bedroom, separated from the rest of the space by low shelves. The roof is used as an exterior terrace. From here one can enjoy splendid views of the valley, the woods, and the ravine and still be shielded from the untamed surroundings.

The outer surface consists of concrete blocks in which the joints have been kept to a minimum, emphasizing the building's sturdy, solid structure. On this skin, a composition of orthogonal lines defines the aluminum fenestration, which opens to the outside. The polished concrete flooring of the patio extends toward the interior, while on the upper level, which contains the more domestic areas, oak floorboards provide a warmer touch.

Simon Ungers
House

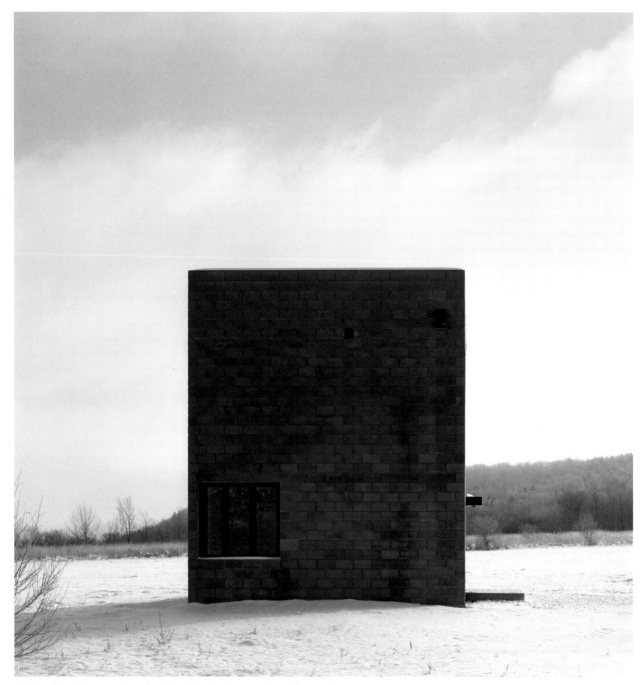

Inside and out, the materials used reinforce the idea of a tiny refuge and monolithic sculpture.

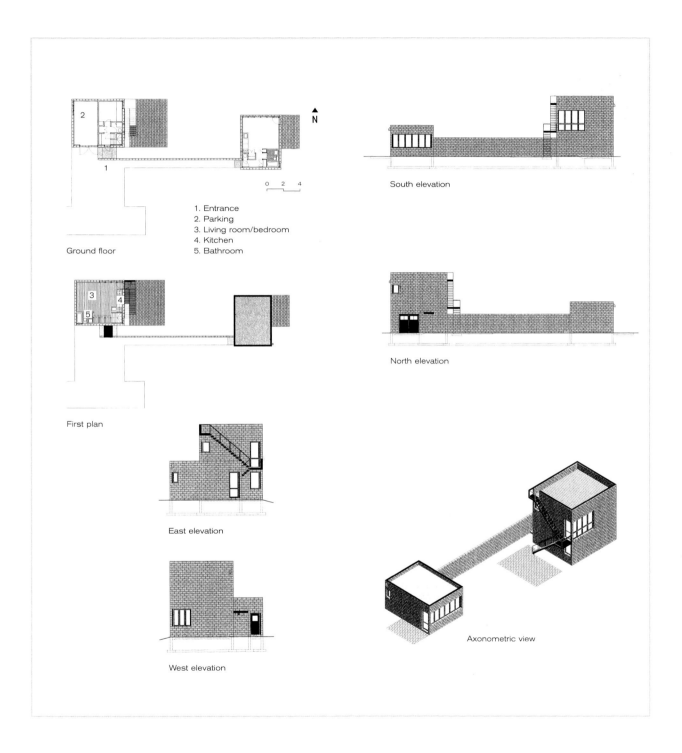

N

Ground floor

1. Entrance
2. Parking
3. Living room/bedroom
4. Kitchen
5. Bathroom

First plan

South elevation

North elevation

East elevation

West elevation

Axonometric view

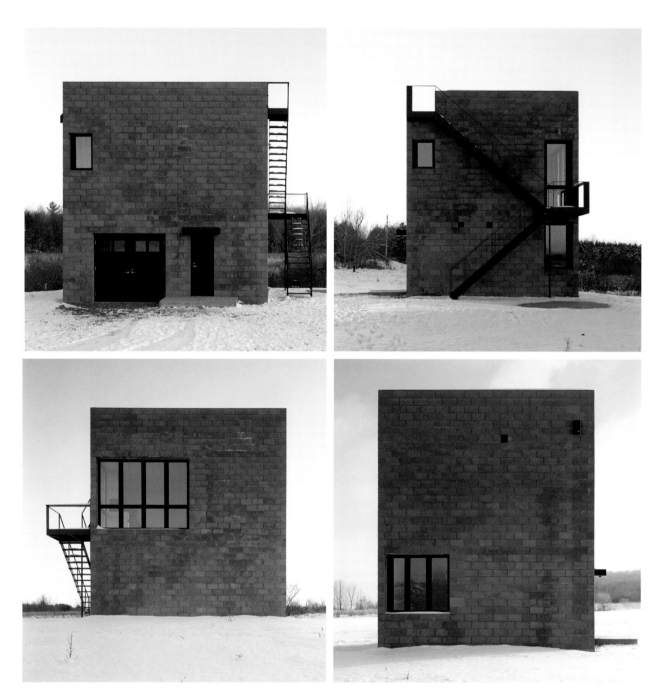

In contrast to the massive volume of the house, narrow metal stairs placed against the exterior wall of the building connect the future ground floor patio with the living area and roof top terrace.

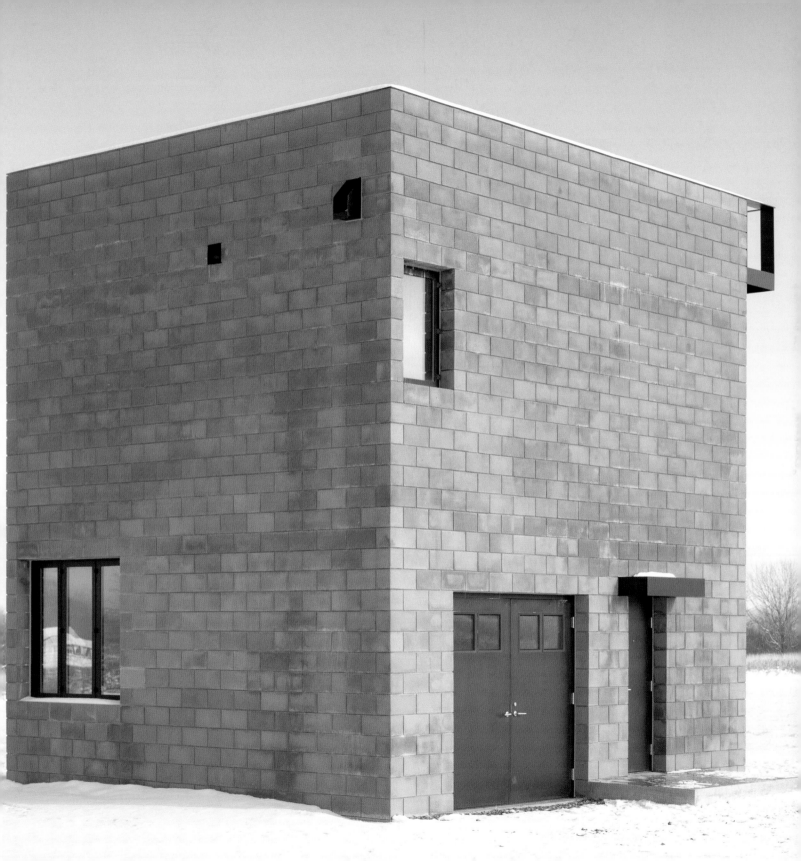

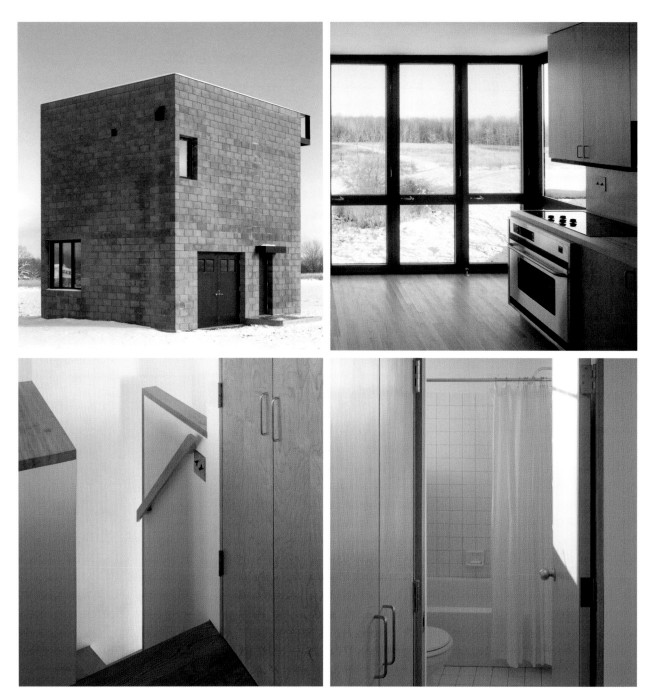

The minimalist approach to details and finishes fully reflects the fundamental nature of the home.

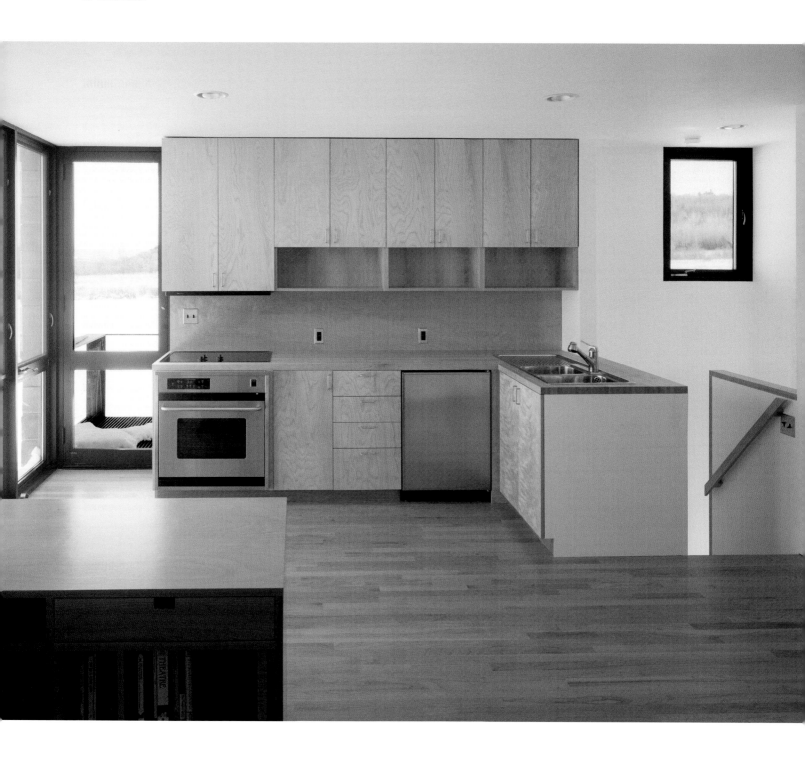

The project involved
the expansion of a
tiny existing house in
this Swiss locality.
Another goal was to
insulate the house
to make it more livable.

House in

FLAWIL, SWITZERLAND 2000 ARCHITECT: WESPI & DE MEURON PHOTOGRAPHER: © HANNES HENZ AREA: **807** SQ. FEET

The project consisted of covering the existing structure with horizontal wooden slats to create a very tight weave. The new skin covers the house's existing outer walls and stretches out 22 feet to the south, the only direction in which the building could be extended. On this side, the only one that opens fully, the slats create the effect of blinds through which the scenery is visable. The result is a simple object; a single unit clearly identifiable with the neighboring houses and granaries.

The solutions for heating and cooling are reflected in the interior layout, the construction, and the use of materials. The service spaces, such as the kitchen, stairs, bathroom, and office, are grouped toward the north. Thus a kind of chamber is created in the most disadvantaged part of the house, protecting the living areas. The almost hermetic wooden finish on the northern, eastern, and western sides contributes to the passive solar effect, while the southern side opens up to receive as much heat as possible from the sun. The wooden slats on this side act like blinds to provide protection during the summer months.

The old house that formed the basis of this expansion and renovation project was one of the first prefabricated wooden structures in Switzerland. This fact was not evident from the outside, since the wooden structural elements were concealed by plaster. In addition, the houses in the region at the time of construction did not have insulating or heating systems to ensure comfort.

WESPI & DE MEURON
Flawil

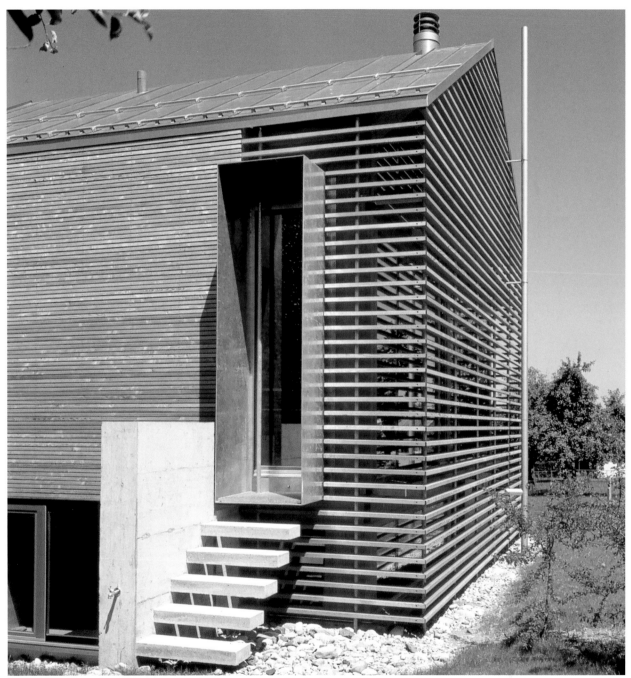

The strategy for expanding the house was based on the appearance of the local farm buildings.

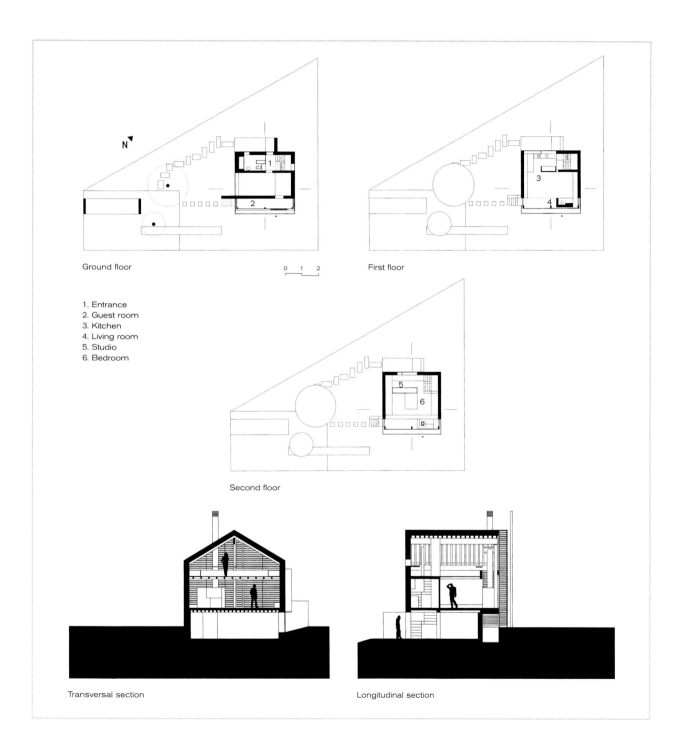

Ground floor

0 1 2

First floor

1. Entrance
2. Guest room
3. Kitchen
4. Living room
5. Studio
6. Bedroom

Second floor

Transversal section

Longitudinal section

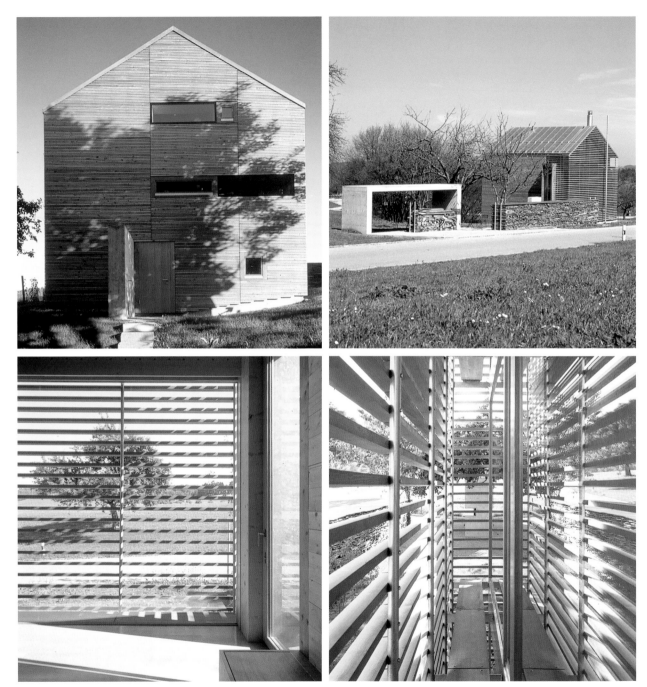

A two-story space, whose continuity is interrupted by the fireplace, runs the entire southern side of the house and links the living and sleeping areas.

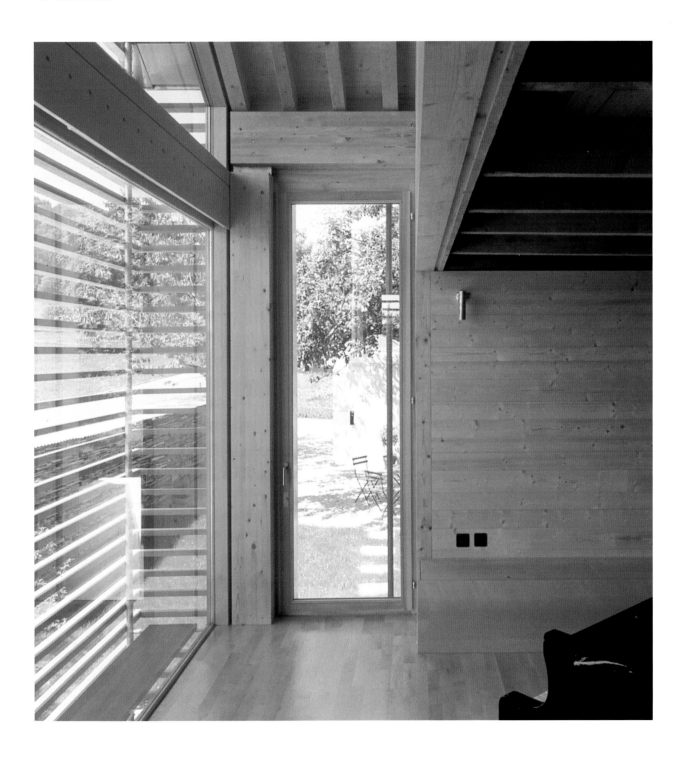

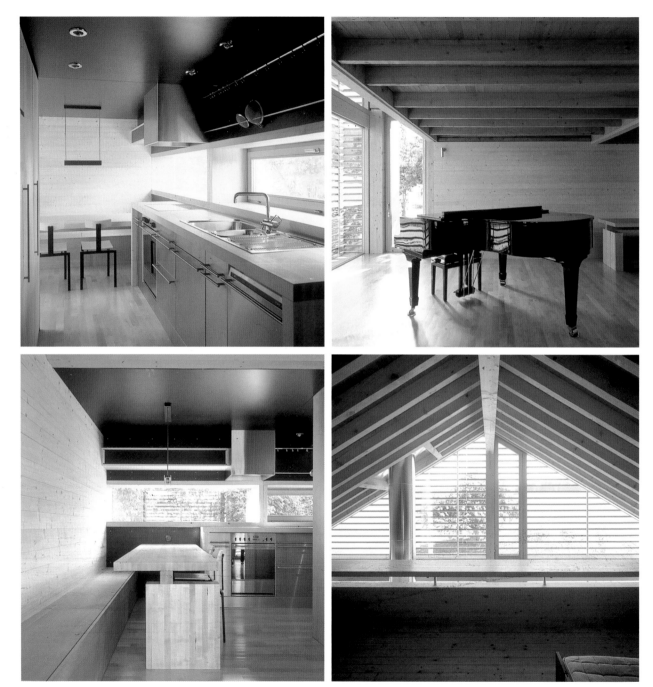

Inside and out, the dominant material is wood. This makes for continuity of appearance and a warm, welcoming atmosphere.

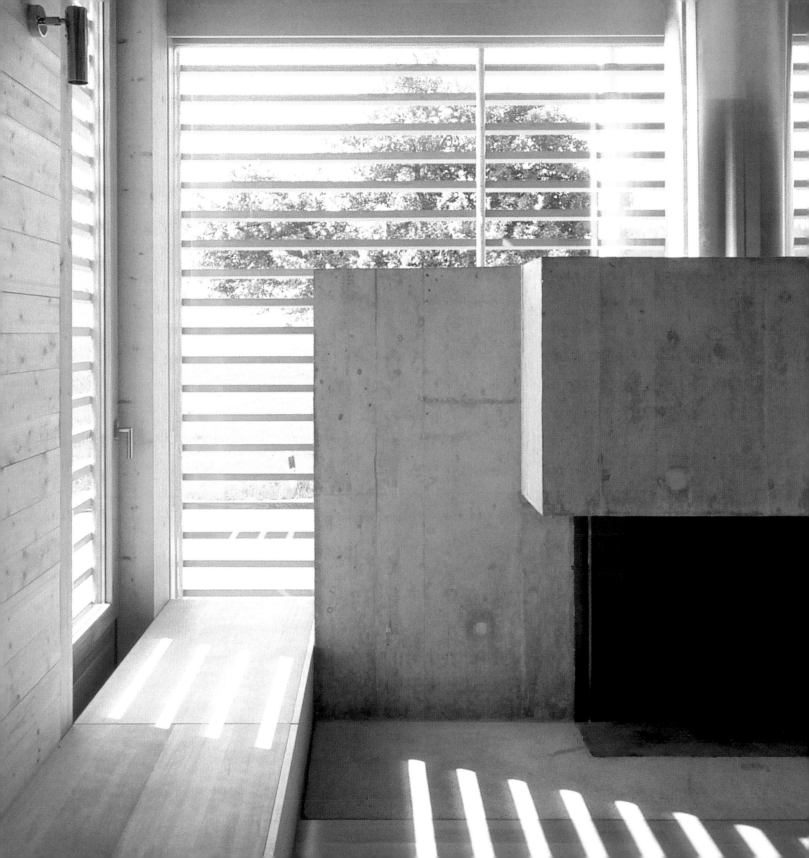

The creation of a unique object was achieved through a basic scheme which involved the use of the current construction materials of the region.

House on the

ISLAND OF OMØ, DENMARK 2001 ARCHITECT: OLE HOLST PHOTOGRAPHER: © OLE HOLST AREA: 764 SQ. FEET

This weekend refuge is located on the island of Omø in southern Denmark, in an area occupied, aside from a village, mostly by farms and small, rural houses built using traditional construction techniques. The plot is on the most remote part of the island, with views as far as the Great Belt – an ideal spot for a hideaway.

The relationship between a basic cubical unit and a structure based on traditional local techniques led to a simple architectural design with great compositional strength. The structure is a wooden box with narrow openings that let light in and enable the residents to enjoy the surrounding landscape. A single large window highlights the most attractive view, toward the sea and the sunset, while another opening, 23 inches high, around the building, frames the rest of the surrounding landscape.

The building is based on an American-style framework covered with plywood, which allows the windows and doors to be placed anywhere. One determinant for the construction was thermal insulation which, in this case, results in great energy savings. The 6-inch thick floors and walls and the 8-inch thick ceilings minimize the amount of heating needed during the winter. Also, the horizontal placement of the exterior wooden slats can deflect up to 40 percent of the sun's rays during the warmest months.

The plan includes a principal space on the ground floor, which houses the combined living room, dining room, and kitchen. In the southern part of the house, the two-story space accommodates a sleeping loft, which is on an upper level but integrated into the general space. Contiguous to the entry area, also on the southern side of the house, is a small guest room, separate from the main unit.

OLE HOLST

Island of Omø

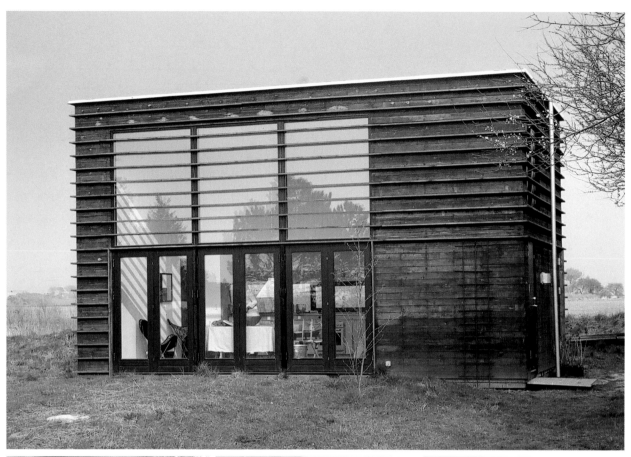

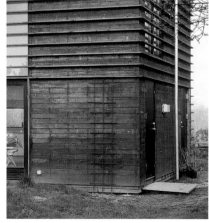

The bi-directional placement of the wooden slats makes it possible to control the entry of light while enhancing the outward appearance with a fine texture.

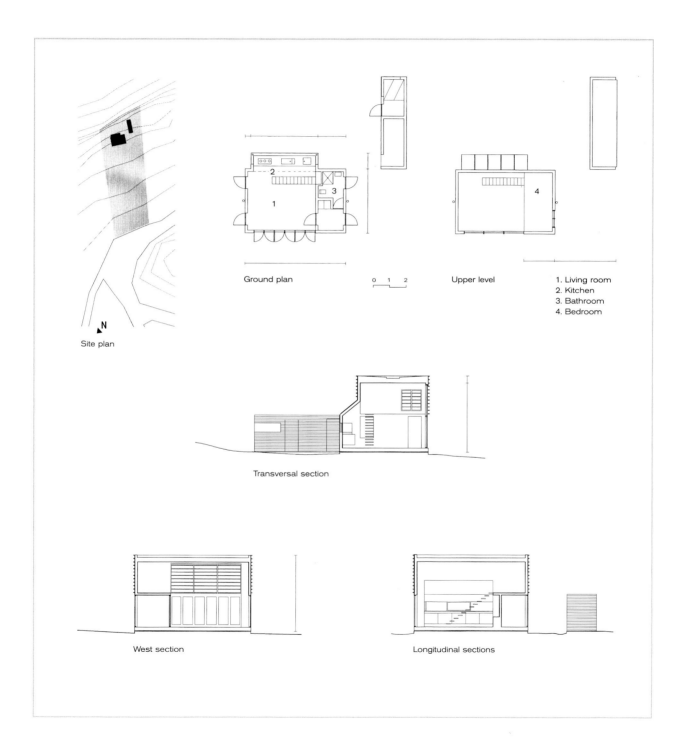

Site plan

Ground plan

0 1 2

Upper level

1. Living room
2. Kitchen
3. Bathroom
4. Bedroom

N

Transversal section

West section

Longitudinal sections

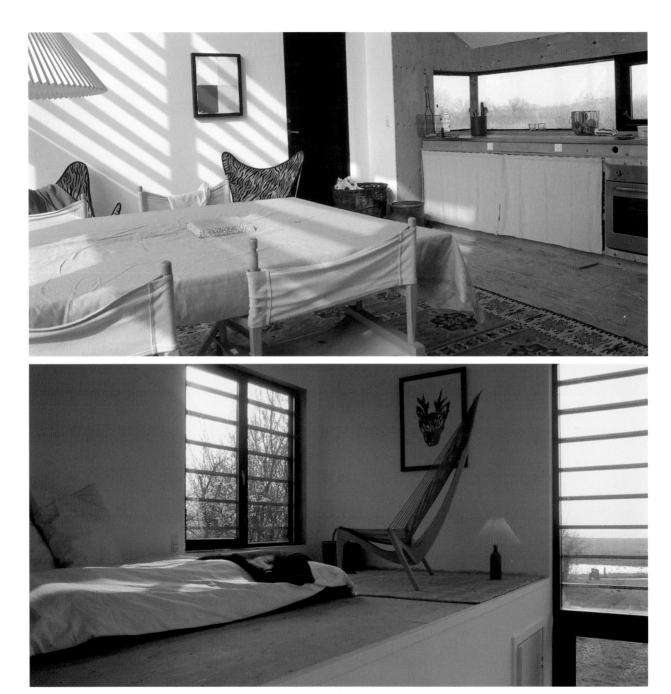

The sleeping area, on an upper level, enriches the interior space by creating different heights.

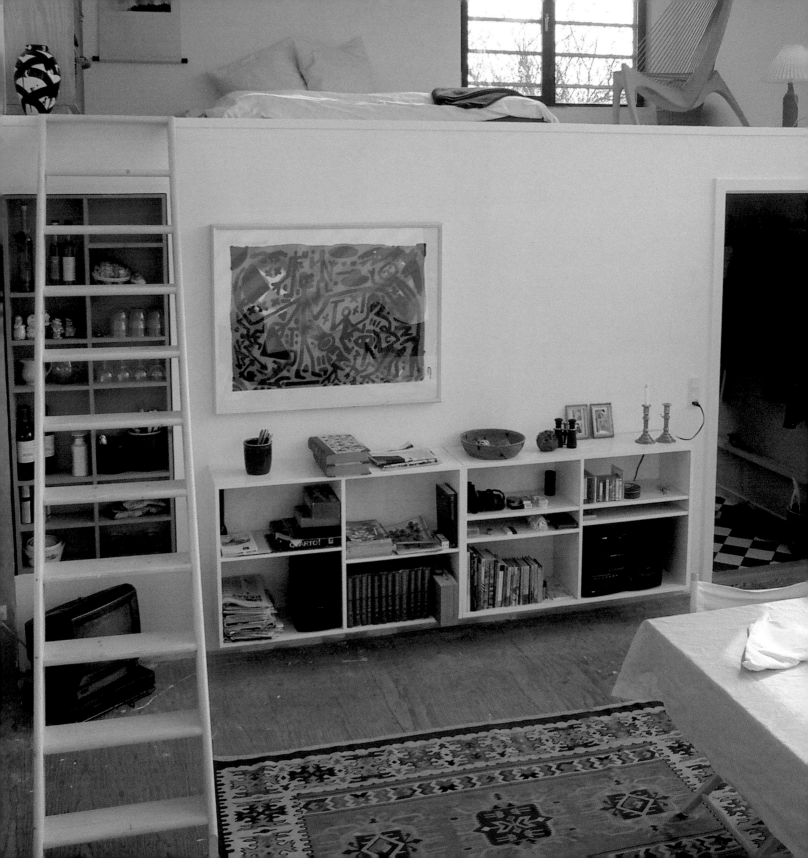

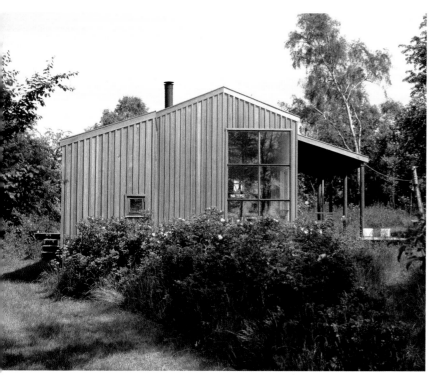

The modest volumetric composition of this house is based on the region's rural housing typology. It is a modest construction that achieves a great quality of interior space and an interesting relationship with the exterior, in spite of its simplicity.

House by

SEELAND, DENMARK 2000 ARCHITECT: **HANNE DALSGAARD JEPPESEN + HENRIK JEPPESEN ARCHITECTS** PHOTOGRAPHER: © **TORBEN ESKEROD** AREA: **721 SQ. FEET**

The house is situated in the northeastern part of Denmark's main island, Sealand, an hour by car from Copenhagen. The landscape here, with dense forests, high altitude, and splendid panoramic views of the valleys and sea, is unique in comparison to the rest of the country. This part of the island has been inhabited for thousands of years, and there are many Bronze Age burial mounds at this particular location. The mounds were generally placed on the highest spots to take advantage of the best views. This small building sits precisely on one of these mounds for just that reason.

The size and positioning of this project were studied carefully from the standpoint of the sun's movement and the views. Actually, the house consists of two units, each complementing the other in both form and function. The first, on the north, is long and narrow, and contains the bedrooms, the entry way and the bathroom, while the other, on the south, is a two-story box containing the living area, dining room, and kitchen. Since the long structure serves as a protective barrier against the strong northern winds, the openings on that side are small and serve only for ventilation. But on the eastern sides the openings welcome the rays of the morning sun, and on the west and south the house is completely open to take advantage of the ocean views and allow sunlight to flood the interior.

The house was built entirely of wood, using a system of vertical cedar slats inside and out. This achieves a formal appearance that approximates that of the region's traditional construction.

The building's lightness is reinforced by the structural system, which uses posts to raise it slightly off the ground, and by a wooden deck that also floats above the ground.

HANNE DALSGAARD JEPPESEN +
HENRIK JEPPESEN ARCHITECTS
the Sea

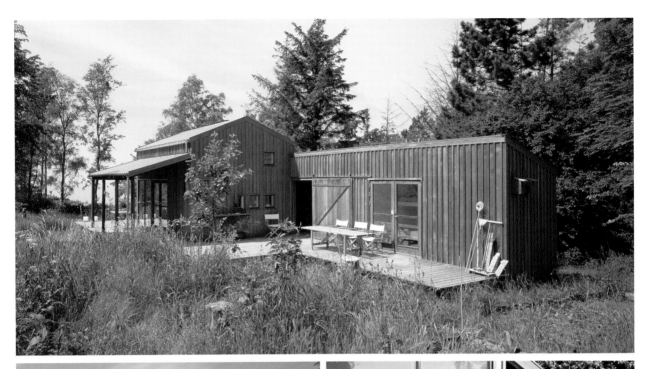

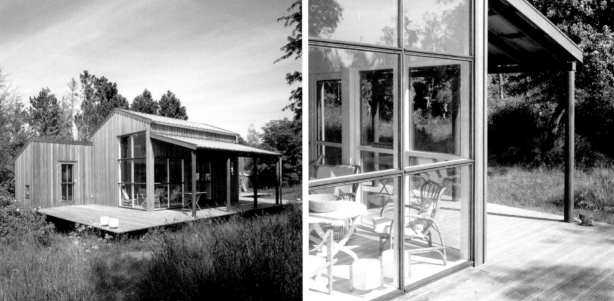

The original intention of this house, designed for the architects themselves, was to achieve a structure closely related to its natural setting, both in the composition of the units and the materials used.

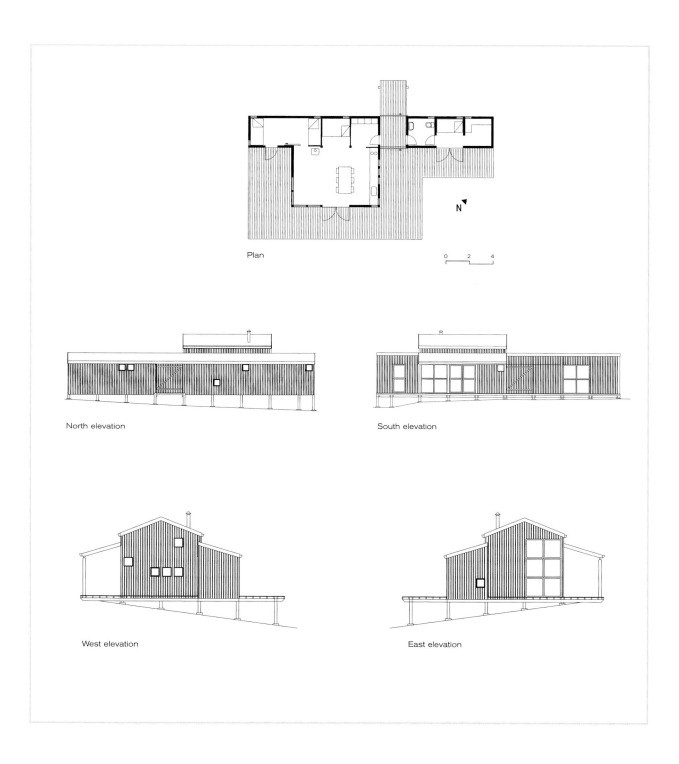

Plan

N

0 2 4

North elevation

South elevation

West elevation

East elevation

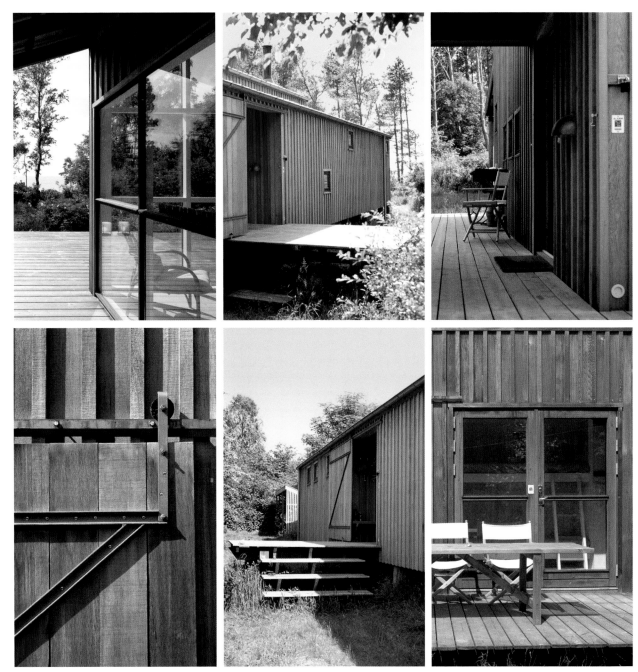

Access is from the long unit, through an opening controlled by two sliding doors between the entrance deck and the principal deck on the south side.

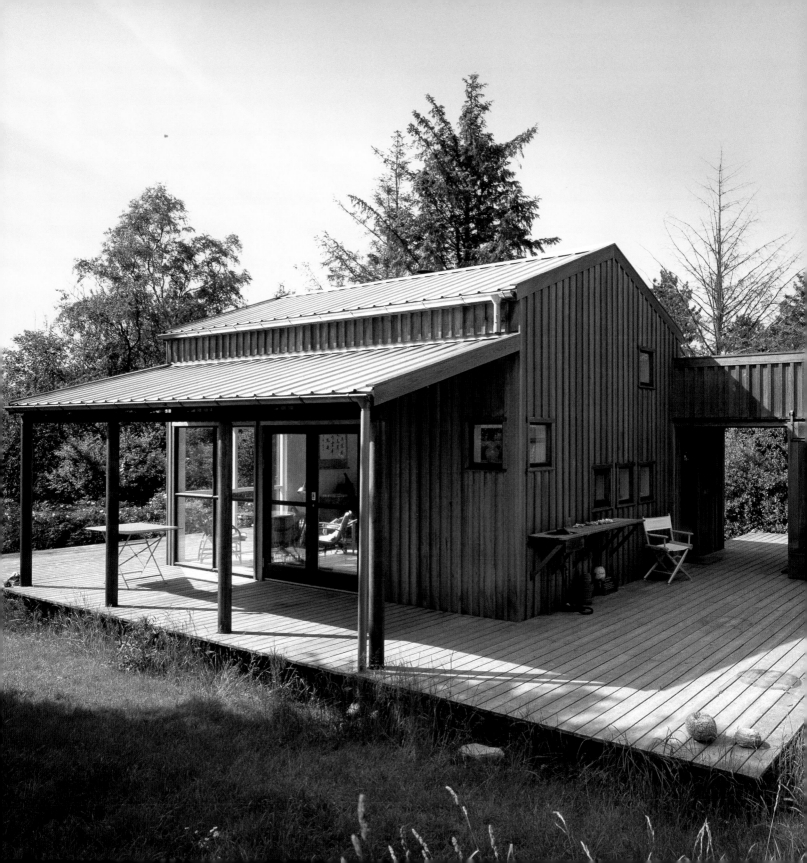

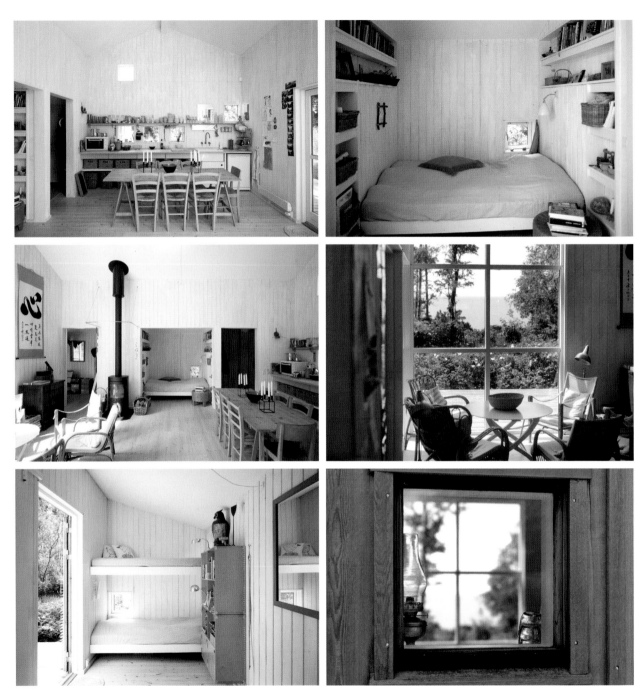

The same cedar strips were used inside, in this case, painted a much lighter color, to finish the surfaces.

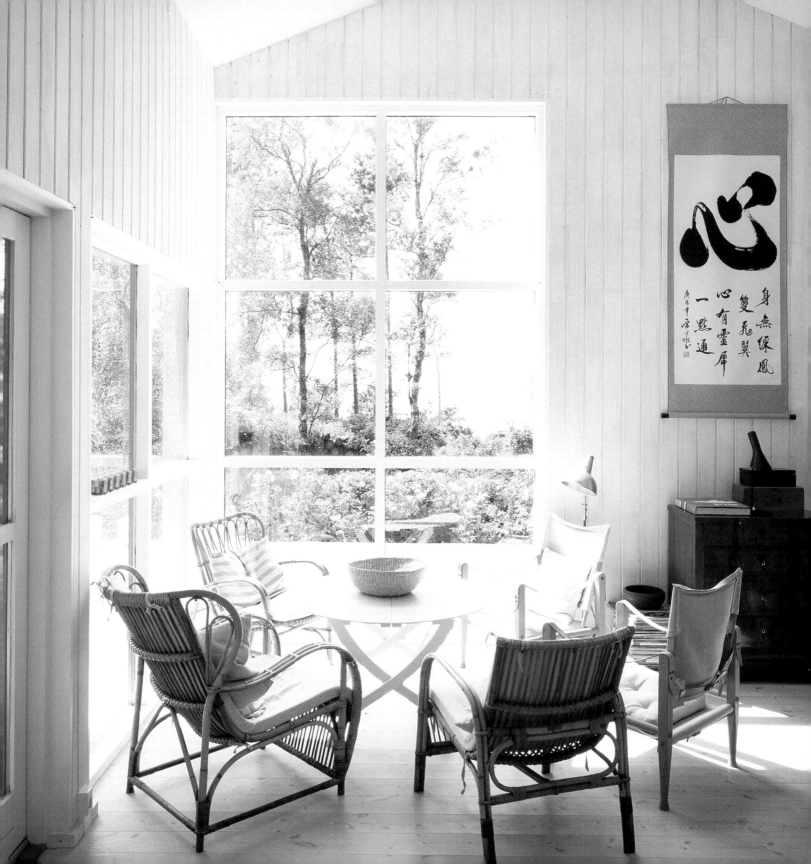

The play of basic
geometric shapes and
objects creates a space
of great formal richness.
The openings to the
exterior are carefully
controlled to take
advantage of the
panoramic view while
isolating the interior from
the immediate neighbors.

House on

WICKENHAM, LONDON, UNITED KINGDOM 2000 ARCHITECT: BOYARSKY MURPHY ARCHITECTS COLLABORATORS: NICHOLAS BOYARSKY, NICOLA MURPHY, MELANIE PERKINS
PHOTOGRAPHER: © HELENE BINET AREA: **699** SQ. FEET

The clients had purchased this tiny property, formerly the site of public baths, on the banks of the Thames River, outside London. The old building was a structure of wood and prefabricated panels to which minor additions had been made over the years. While the location offers outstanding natural conditions, the existing structure was in an advanced state of deterioration.

Having submitted the winning bid for the design and construction of the house, the architects implemented their strategy to adapt the building and turn it into a small habitable space. They retained the concrete foundations and some of the wooden framework, now under a new roof that orients the house toward the river, isolates it from the access bridge, and introduces a series of new elements that define the house's lifestyle.

The roof, comprised of two juxtaposed, inclined planes, floats above the building and is supported by small circular columns anchored to or built into the walls. Thus, the entire roof is separated from the exterior walls and, moreover, is opened up by a clerestory that runs the length of the building. This continuous window affords an unbroken panoramic view of the sky and trees, but not of the immediate neighbors.

The façade was replaced by a metal frame which supports a sliding double-glazed door. This element opens the interior to a wooden deck and the river beyond. The rest of the interior divisions were eliminated, and the new layout is marked by walls that do not reach to the ceiling, allowing for the continuous clerestory and creating a feeling of spaciousness throughout the house. All the doors – both interior and exterior – are sliding, for better integration of the spaces.

BOYARSKY MURPHY ARCHITECTS
Eel Pie Island

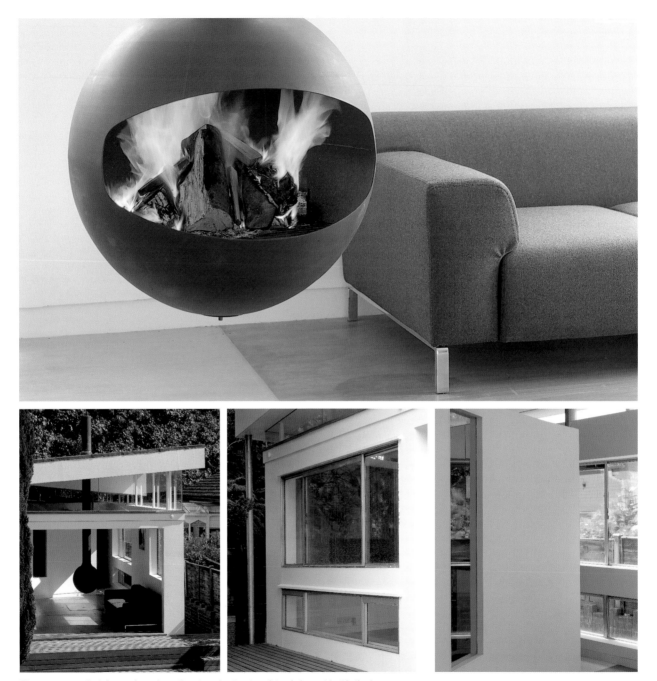

The iron stove, which hangs from the ceiling, is a dominant sculptural element inside the house.

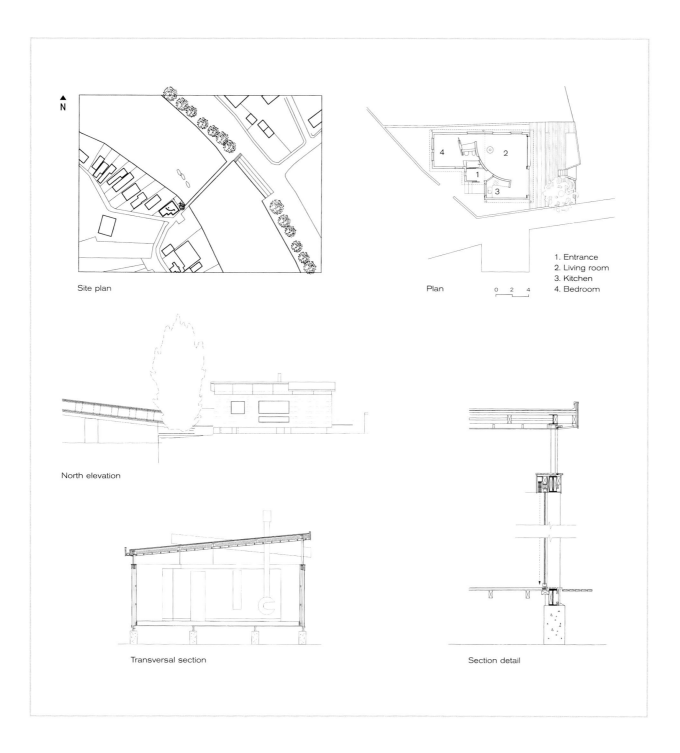

Site plan

Plan

0 2 4

1. Entrance
2. Living room
3. Kitchen
4. Bedroom

North elevation

Transversal section

Section detail

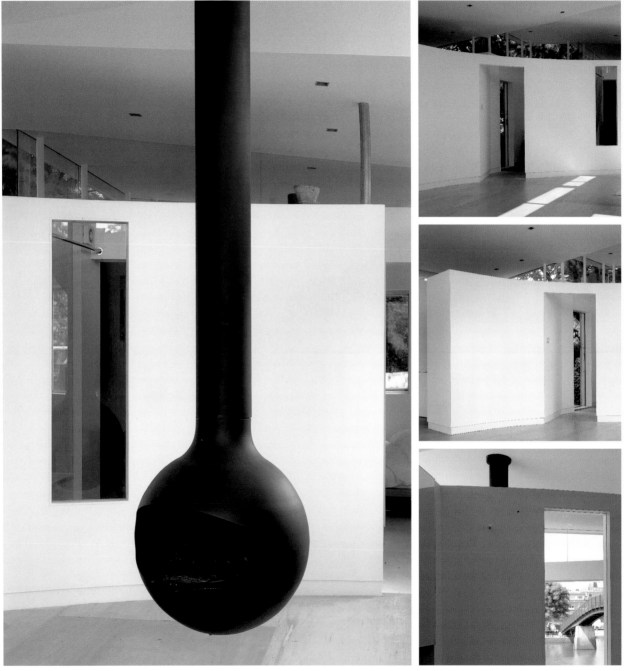

A curved wall separates the home's public and private spaces. Behind it is the kitchen, access to the bathroom, the bedroom, and a small office, from which the view of the river can be enjoyed through openings in the wall that create interior windows.

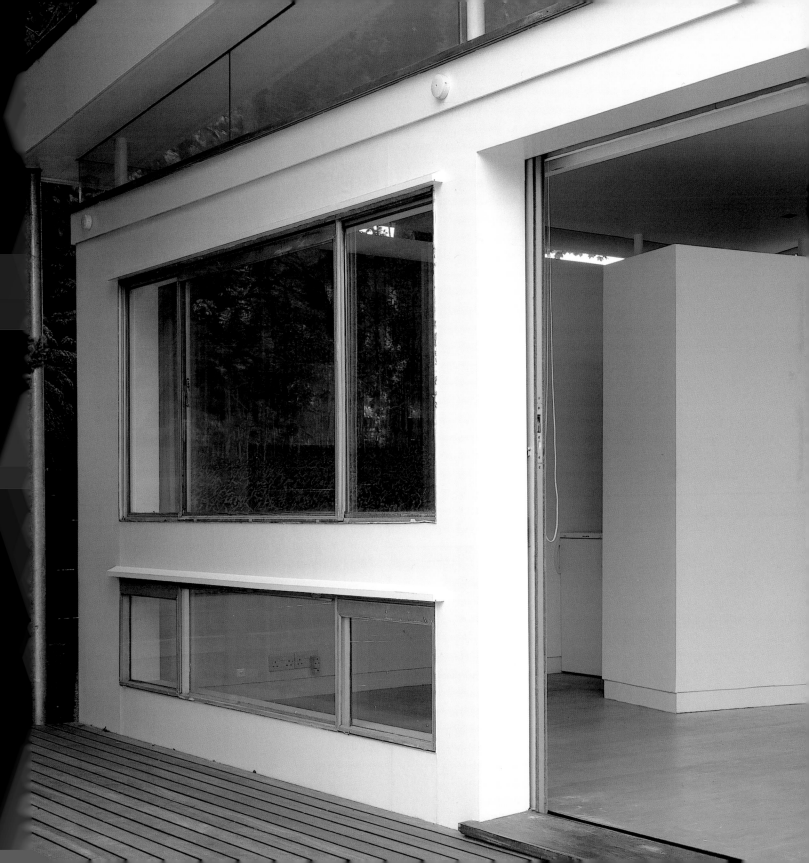

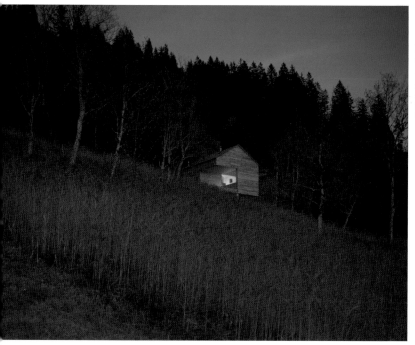

The clarity and simplicity
of this project are evident
in its structure and
appearance as well as in
the interior layout.
To achieve this powerful
combination, the
architects used a cross-
shaped plan that is in
keeping with the plot and
the client's desires.

Maiensäss

FANAS, SWITZERLAND 1999 ARCHITECT: **BEARTH & DEPLAZES ARCHITEKTEN** PHOTOGRAPHER: © **RALF FEINER** AREA: **700** SQ. FEET

This project entailed rebuilding an old mountain cabin that stood on the same site and was almost totally destroyed by fire some years ago. The design uses the existing plan and the vernacular architecture of the region as references to create a building with an austere, restrained, contemporary design. Its appearance, however, is suited to its isolated location: a small, flat, rocky surface in the midst of the Swiss Alps, accessible only by cable railway or on foot.

At first sight, the structure seems monolithic and totally closed off from the outside. Two large pieces of the façade slide on tracks to open a quarter of the house to the outside. From here, a large window looks out on a panoramic view – a clever way to include a large exterior opening, otherwise prohibited by local regulations. This strategy accentuates a very close relationship between the indoors and outdoors while allowing the house to be completely closed when unoccupied.

Larch wood is the dominant material, since it coordinates with the architectural style of the region as well as being readily available and easy to transport and use. The walls are constructed of wooden frames covered by wood panels inside and horizontal slats on the outside, which gives texture and scale to the house from a distance. The air chamber formed by the frames supporting the two faces of these walls ensures better thermal insulation.

The interior layout is based on a plan as clear and simple as the house's structure. It divides the area into four square rooms of the same size, separating the different rooms while establishing a relationship between them in which each is a preamble to the next.

BEARTH & DEPLAZES ARCHITEKTEN
Cabin

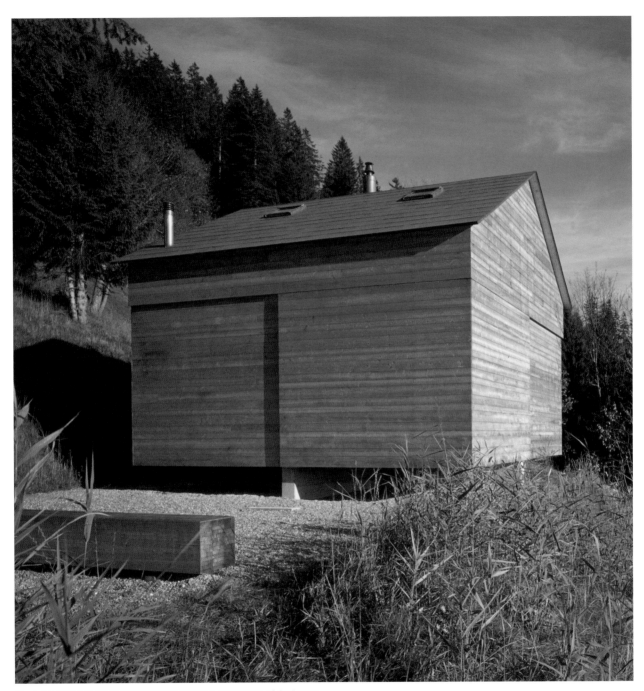

Two large sliding doors totally change the hermetic appearance of the house.

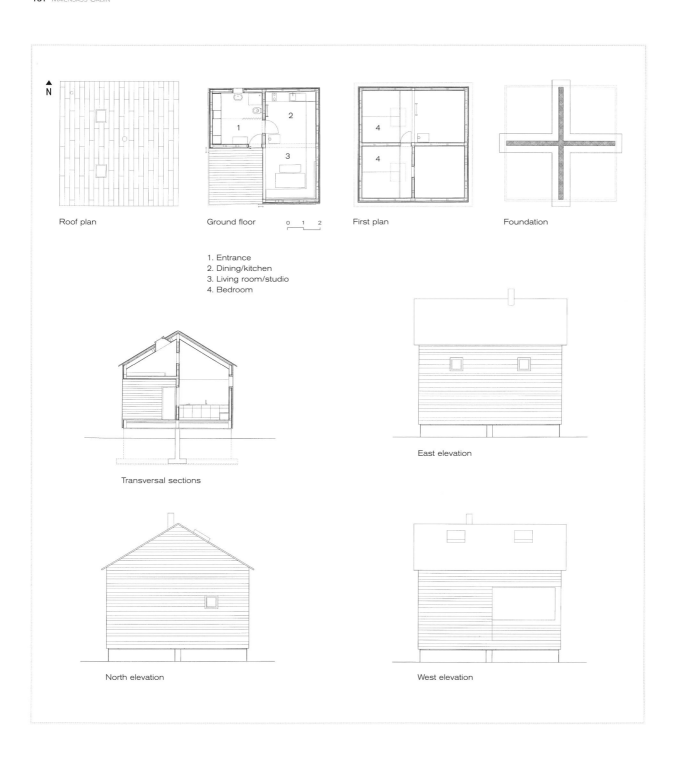

N

Roof plan

Ground floor

0 1 2

First plan

Foundation

1. Entrance
2. Dining/kitchen
3. Living room/studio
4. Bedroom

Transversal sections

East elevation

North elevation

West elevation

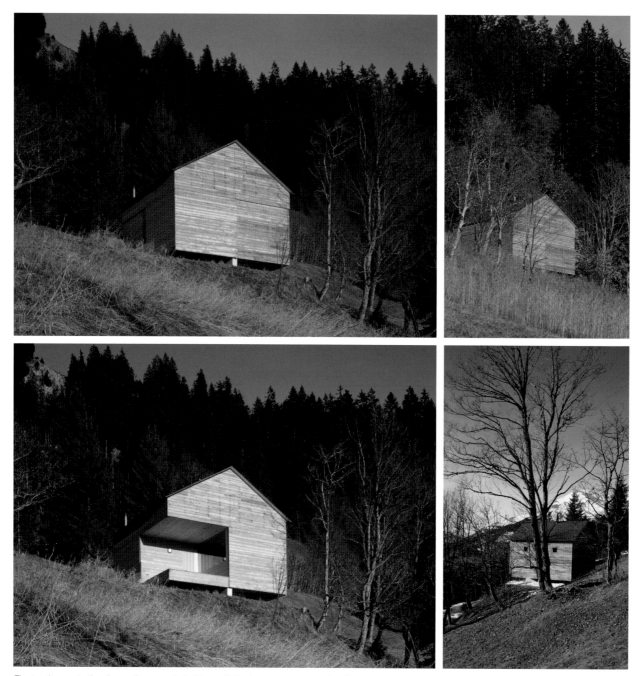

The two beams in the shape of a cross that sit beneath the house are concrete but, because they are rectangular and placed out of the sunlight, they resemble larch wood.

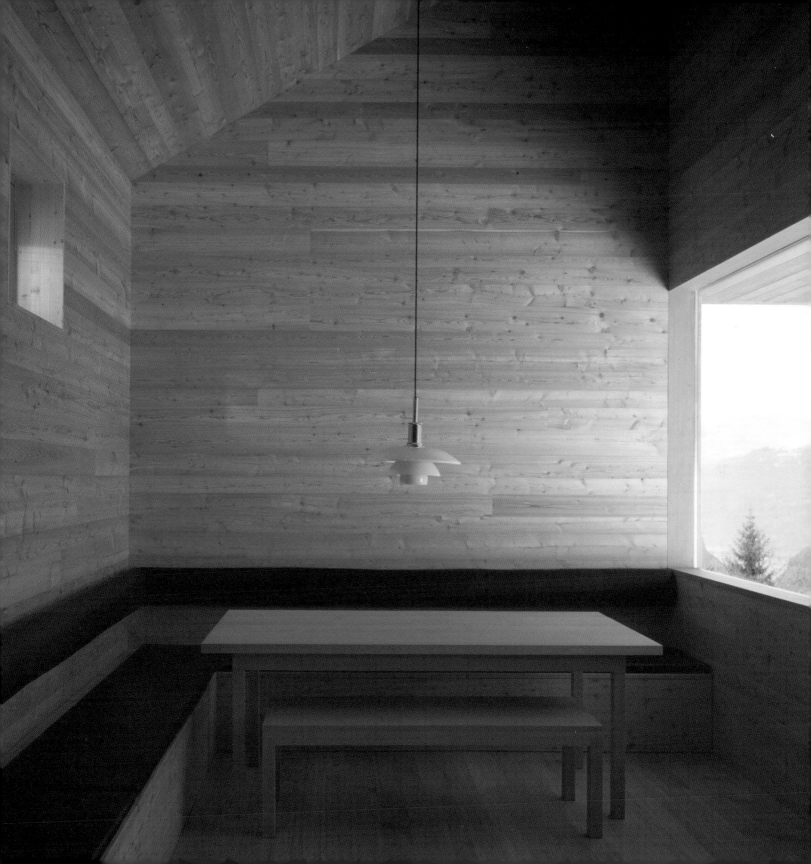

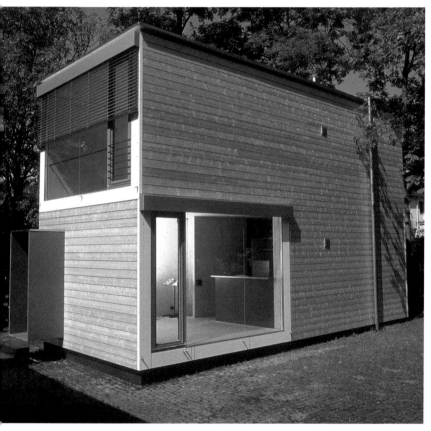

The principal challenge was to create a compact home with prefabricated components that would be easy to put together but very comfortable and adaptable to different needs.

Small

MOBILE 2000 Architect: Bauart Architekten Photographer: © Andreas Greber, Haesle-Rüegsau Area: **678** sq. feet

The home is a small container with regular rectangular proportions, optimized for maximum spatial and functional efficiency. Each of the four outside walls has a large window that connects the space to the surroundings while providing natural light and ventilation to all the rooms. Its proportions give the house a sculptural appearance.

The structure consists of a system of prefabricated wooden frames finished with wooden panels and strips. The foundations, also prefabricated, can be assembled on site, and the whole house can be put up in a single day. Moreover, the carefully planned structure and the dimensions of the building allow it to be moved anywhere. In short, it is a simple but very comfortable home.

One floor contains the public areas, while the other is devoted to private space. On the lower floor, the continuous space is divided by a central unit that houses the kitchen. Directly above it is the bathroom. The stairs, along one side of the rectangle, direct traffic along the length of the interior. Natural wood is the dominant material inside, while the red-painted panels serve as a counterpoint and distinguish the service areas.

The Small House project, promoted by Architectureforsale, features a prefabricated home that can be set up anywhere and is adaptable to different needs. It can be an extension of a growing family's home, an independent house for one person, or a private office. Versatility, ease of transport, and simple assembly were the project's objectives.

Bauart Architekten
House

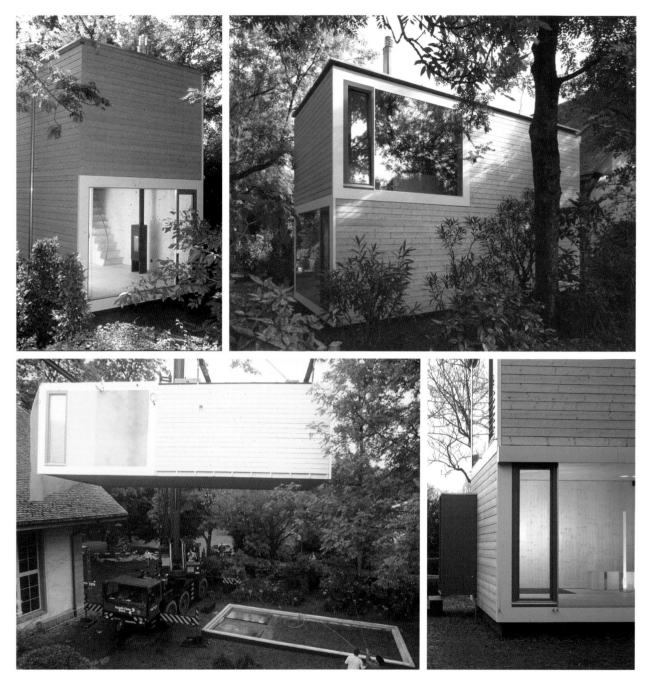

The large windows ensure a close relationship with the exterior while making the interior seem much bigger.

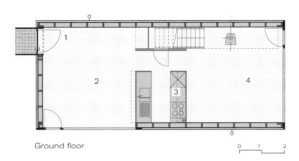

Ground floor

1. Entrance
2. Living room
3. Kitchen
4. Dining room
5. Bedroom
6. Studio
7. Bathroom

0 1 2

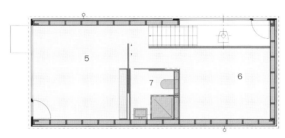

First floor

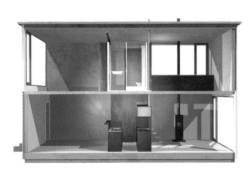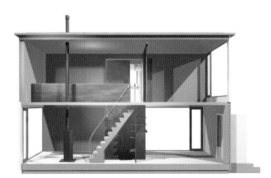

Longitudinal sections

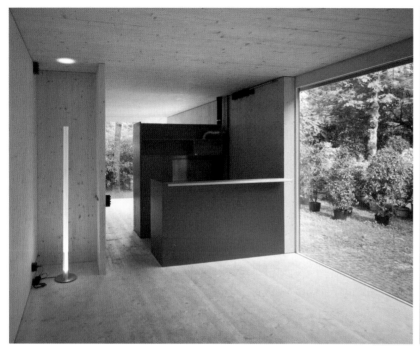
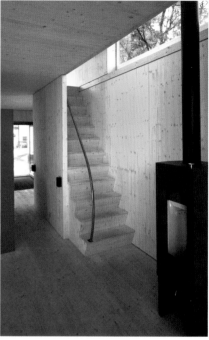
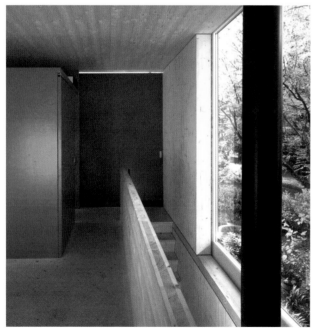
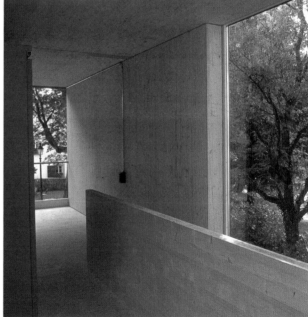

Inside, the same materials used for the outer structure provide a warm, comfortable atmosphere.

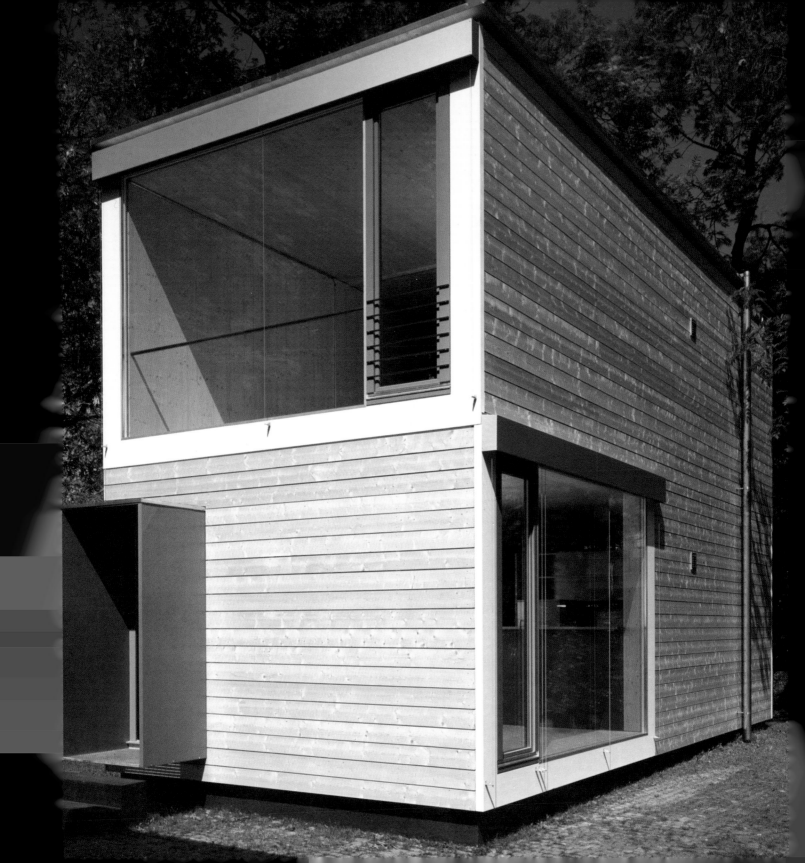

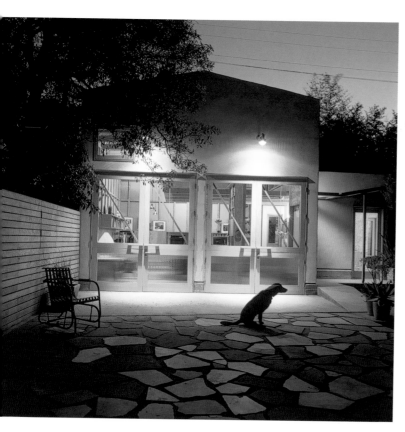

This small home,
a former garage,
reconciles the various
factors of its surroundings.
It respects the functional
characteristics of the
garage while establishing
a close relationship
between the interior
and exterior.

Studio

LOS ANGELES, CALIFORNIA, UNITED STATES 2001 ARCHITECT: DRY DESIGN PHOTOGRAPHER: © UNDINE PRÖHL AREA: 646 SQ. FEET

Different planes on different levels accommodate the various household functions and enrich the interior space. The first plane, which constitutes the ground floor, is a polished concrete slab where a lot of activity takes place. In the main unit, the kitchen, dining room, living room, and studio share a common space, while a small adjacent unit contains the bathroom. Another, intermediate plane, suspended by a framework that hangs from the ceiling, is a wooden loft containing the bed. A roof and small garden over the bathroom constitute a final, exterior plane.

The relationship between the interior and exterior, like the relationships among the various spaces, was arranged to achieve maximum flexibility. Thus, the building can be used as a studio, guest apartment, or independent home. The wooden platform that hangs from the ceiling can also be used as a reading nook or storage area, while the bathroom is independent from the other spaces and can be accessed from the outside. Two large double doors fully integrate the interior with the exterior and allow for the structure to be easily converted and used as a garage again at some point.

This project consists of a small studio and home for the architects' own use in what was once a garage in Mar Vista, a neighborhood in Los Angeles, California. The tiny piece of land on which the former garage sits is surrounded by backyards and single family homes dating from the 1930s to the 1950s. Elements that blend with the surroundings and objects that are introduced inside and out combine to achieve a complex layout camouflaged as what looks, from the outside, like a simple residence.

DRY DESIGN
3773

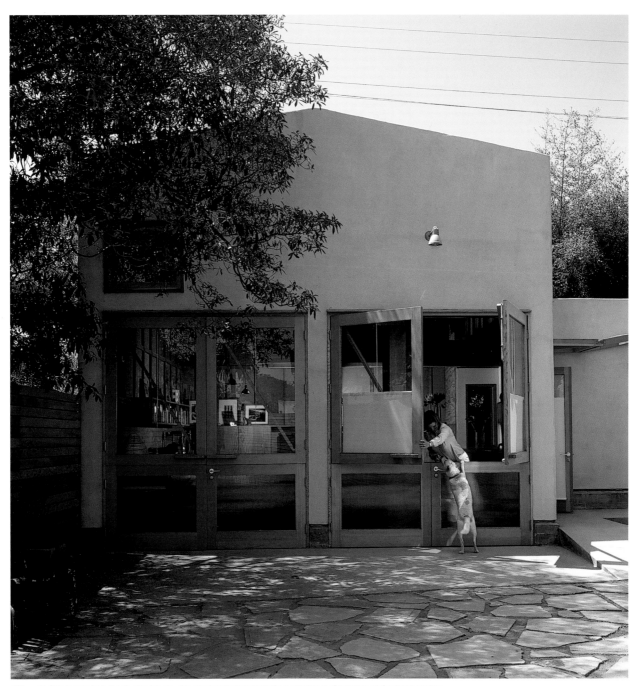

Although this home is in back of a house, the garden that surrounds it creates a charming and private setting.

Interior elevation

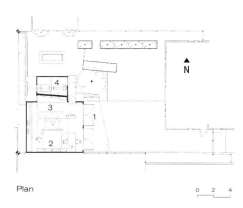

Plan

N

0 2 4

1. Entrance
2. Living room
3. Dining / kitchen
4. Bathroom

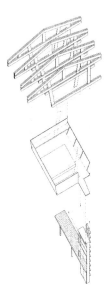

Axonometric view

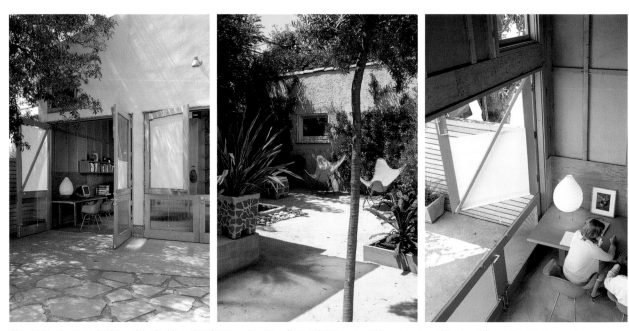

The double doors on the front of the building allow for several options, from isolation to complete integration of the house's interior with the garden.

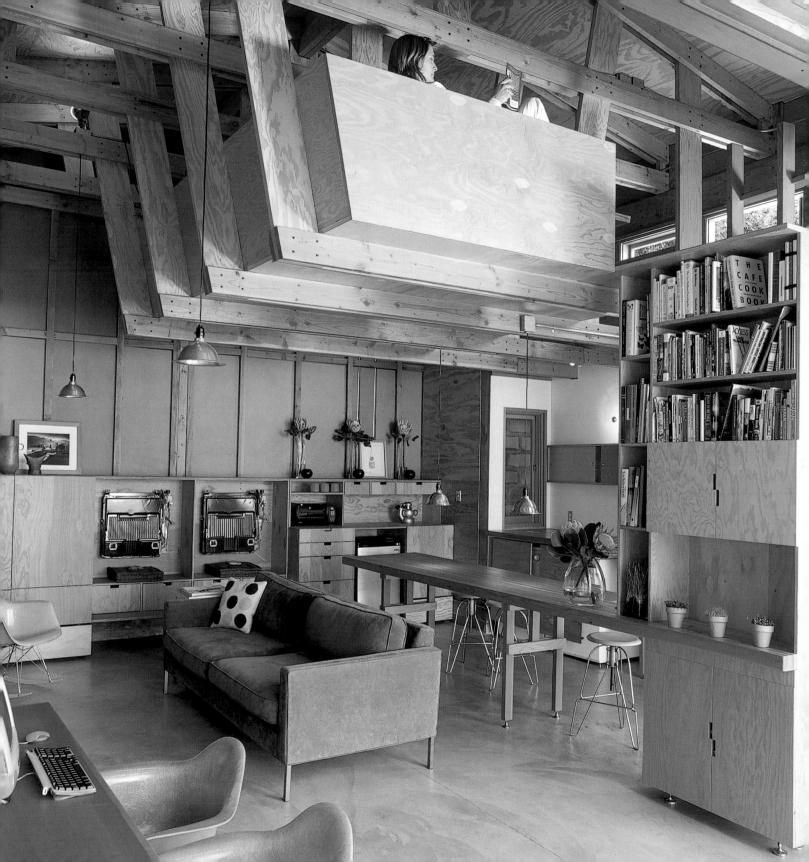

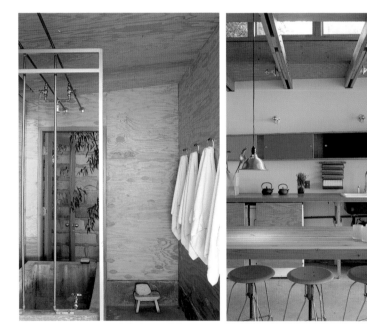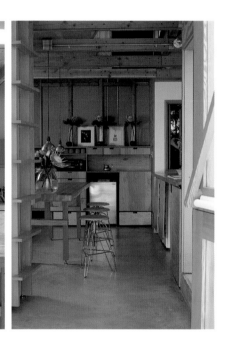

All the interior surfaces are made of plywood panels for good insulation and a rich texture.

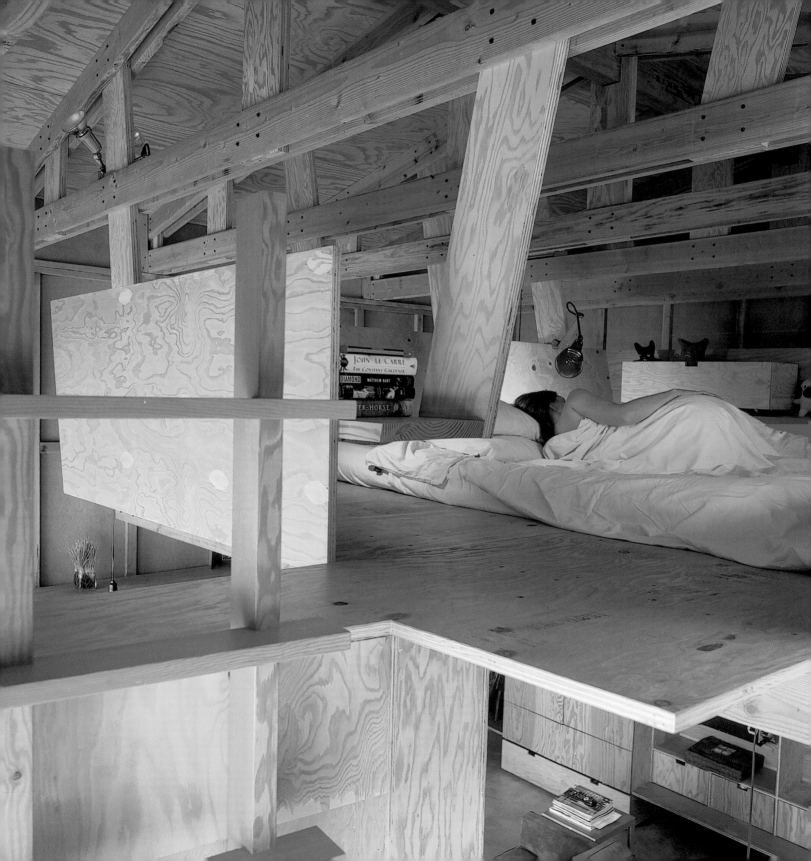

The houses are in a remote mountain location, part of a village of not more than 150 residents. From here one can enjoy panoramic views of Lake Maggiore, on the Italian border, and the surrounding forests.

Stone

CAVIANO, SWITZERLAND 2001 ARCHITECT: WESPI & DE MEURON PHOTOGRAPHER: © HANNES HENZ AREA: 592 SQ. FEET

A group of old structures that once housed stables in Caviano, Switzerland, was the starting point for three small weekend homes. The original stone structures, the splendid views, and the desire for comfortable interiors were the principles that guided the designers.

Since the buildings are small and close together, the architects had to look for ways to capture as much natural light as possible. But at first sight the observer is hard put to see any difference between these buildings and the other houses in the area, except for the iron doors and windows anchored to the façades with steel fittings – signs of the subtle renovation.

The preservation and consolidation of the stone structure were fundamental to the creation of the monastic image in which the old and new complement each other. The stone's texture was restored, even inside, where it was not covered up with any finish that would hide its beauty. Parts of some walls were knocked down and re-used to support other parts where the stone had deteriorated, and some openings were widened to admit more natural light. Doors, windows, stairs, and furnishings have a restrained appearance, with smooth textures that contrast and interact with the existing walls.

Few standard elements were incorporated into the project; most of the furniture was designed by the architects themselves. A table and two benches anchored to a rail on the wall can be moved around in the room or used as a guest bed. The dark sheet metal stairs contrast with the white concrete and the texture of the stone, creating a sculptural effect. The result is a space that respects its original character but also achieves a contemporary, comfortable atmosphere.

WESPI & DE MEURON
Houses

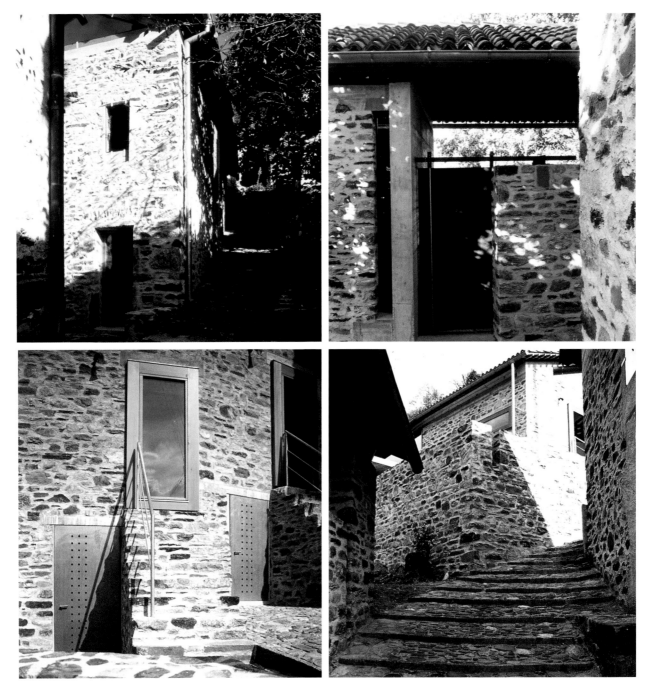

The houses differentiate from the existing architecture in their treatment of light, their urban contest and the nature that surrounds them.

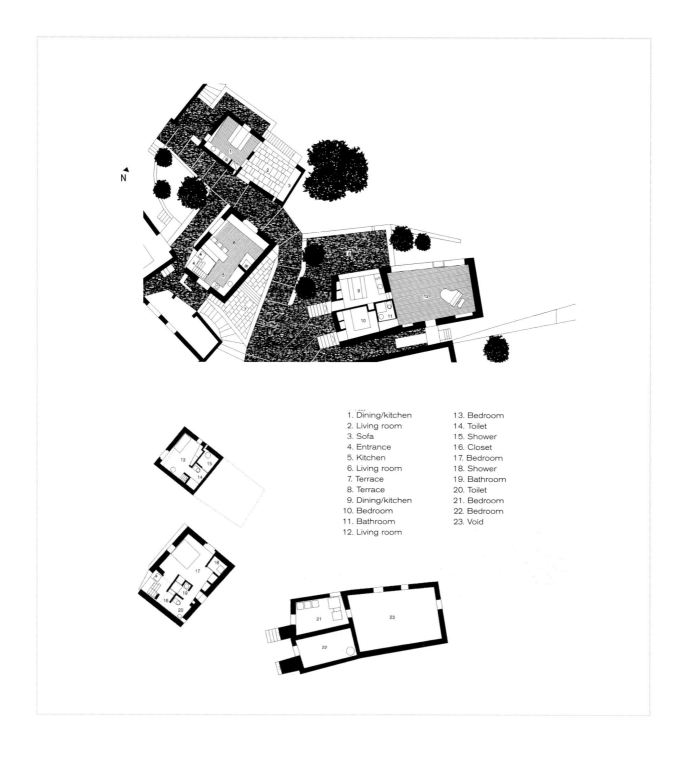

1. Dining/kitchen
2. Living room
3. Sofa
4. Entrance
5. Kitchen
6. Living room
7. Terrace
8. Terrace
9. Dining/kitchen
10. Bedroom
11. Bathroom
12. Living room
13. Bedroom
14. Toilet
15. Shower
16. Closet
17. Bedroom
18. Shower
19. Bathroom
20. Toilet
21. Bedroom
22. Bedroom
23. Void

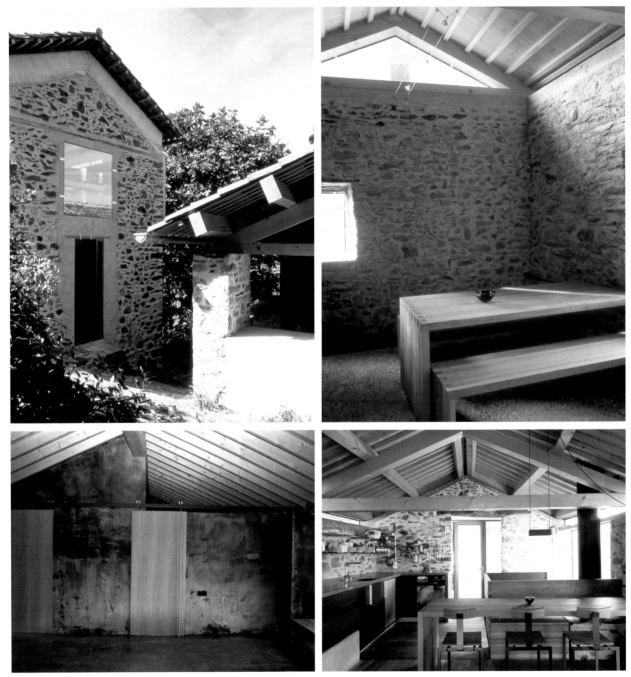

The furniture, sliding doors, and window frames are larch wood, which is the primary material inside the dwelling.

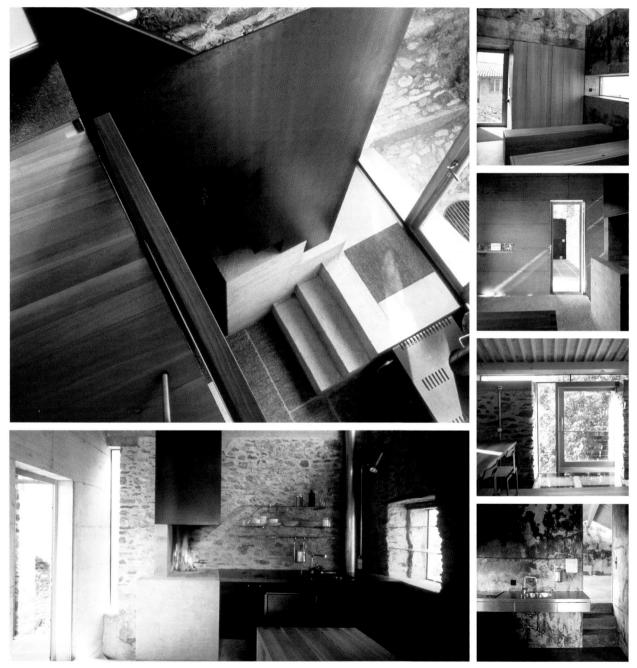

Various openings capture the light and create a sensation of spaciousness. These range from small fissures in the façade to glass that replaces the upper floor framework, letting the light shine through to the ground floor.

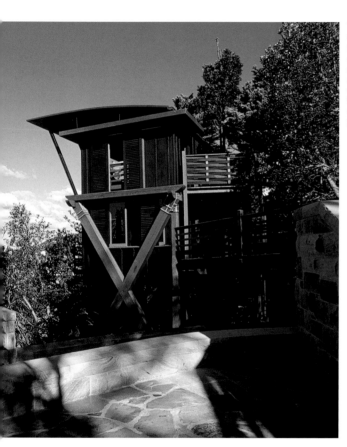

The type of building that was desired, based on a light structure built on a cliff, used a prefabricated system similar to bridge construction. The goal was to have as little impact as possible on this area of great natural richness.

Tree

NEW SOUTH WALES, AUSTRALIA 1999 ARCHITECT: **DAWSON BROWN ARCHITECTURE** PHOTOGRAPHY: © ROBERT BROWN AREA: **592 SQ. FEET**

The idea behind this extension of a 1920s summer house was to preserve the values of the existing structure and its natural setting as much as possible. Palm Beach, a seaside locale in northern Australia, has always been considered a place of great natural beauty where one can find wonderful early- and mid-twentieth century cabins. The owners of one of them found the space insufficient, even for a temporary residence, and decided to expand. After studying several possibilities, the architects arrived at a plan in which the addition, a small, slender wooden building, would be separate from the house. This shape was the source of the name by which many know it: tree house.

The independent construction made it possible to preserve the scale of the existing house and create a building with its own personality. Although the materials used are similar to those of the original house, especially the solid elements and wood panels, the final result is very different. The verticality that predominates in the new building contrasts with the horizontal composition of the old building.

The construction system, which used prefabricated wooden components, made it possible to preserve a great deal of the plant life, both during construction and in the building's final form, giving it the appearance of a garden sculpture. Access is via stairs from the ground or by a terrace that extends from the old house to the base of the building. It is divided into two spaces, one per level. One contains the principal room and the other contains a space that can be used as a living room or guest room, as the need arises.

DAWSON BROWN ARCHITECTURE
House

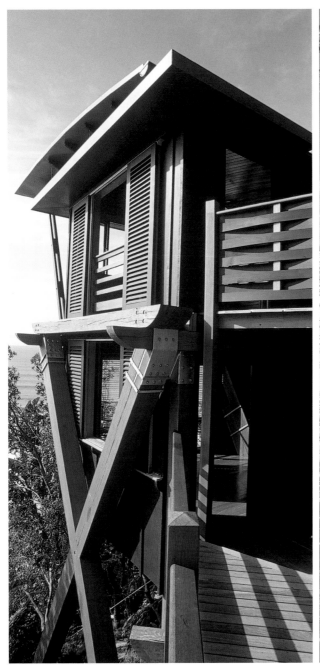 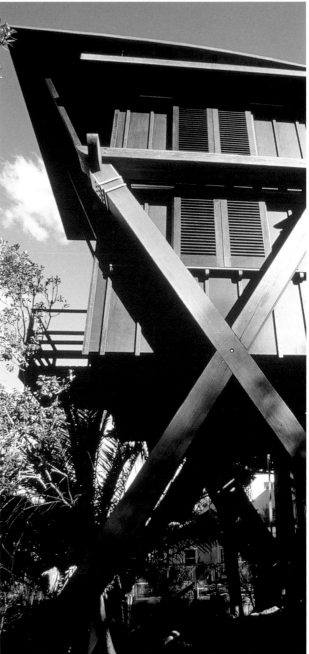

The tree house, constructed of wooden components anchored with metal parts, was built with special care to minimize the effect on its natural setting.

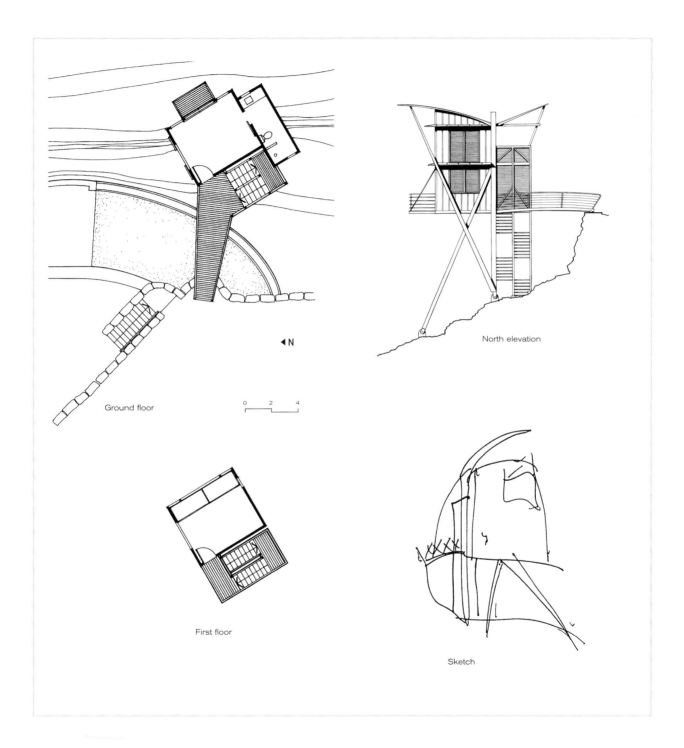

Ground floor

◀ N

0 2 4

North elevation

First floor

Sketch

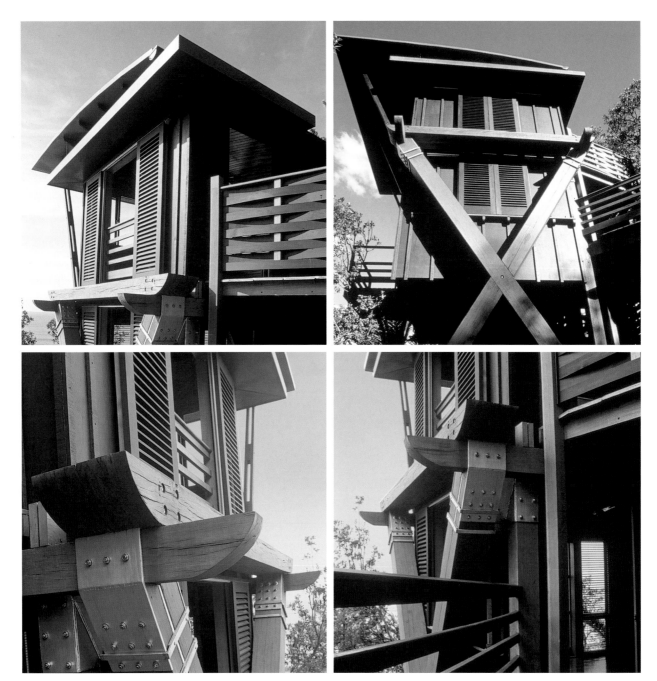

The new building took advantage of vistas of the surrounding forest and the open sea that could not previously be enjoyed from the existing house.

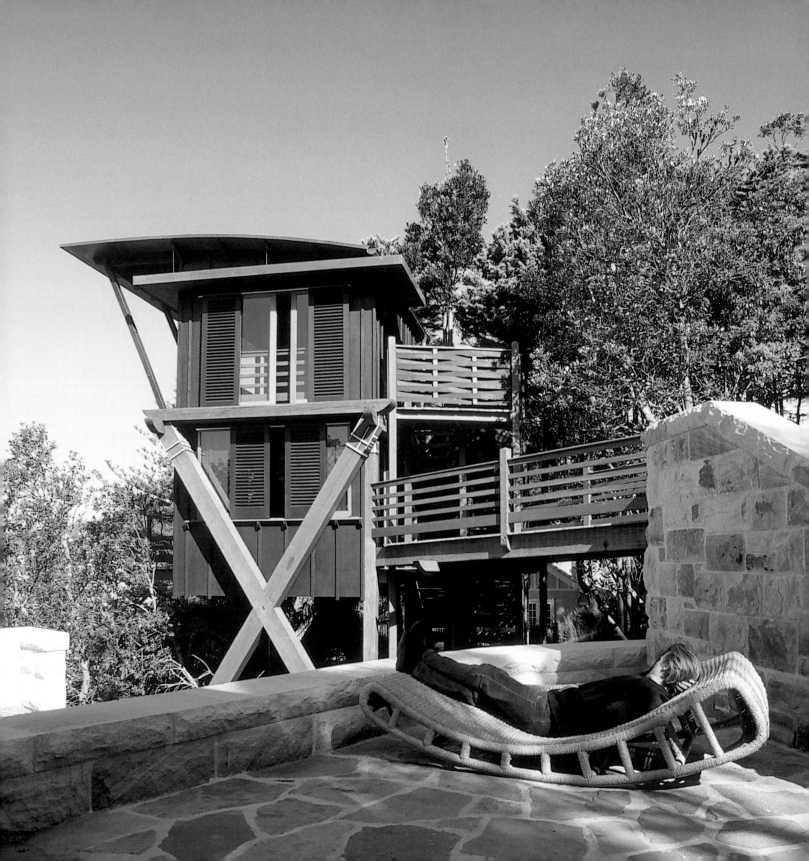

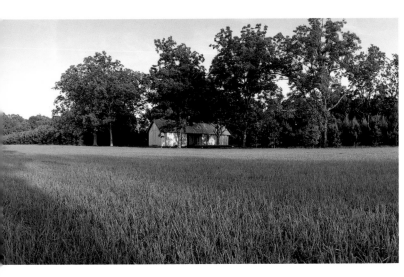

The abstraction of space and form on which the project is based connects the home with local and universal housing concepts. The austere appearance, bereft of detail, is achieved through the use of a continuous sheet of metal all over the walls and roof.

House in

Louisiana, United States 2000 Architect: Stephen Atkinson Photography: © Chipper Hatter Area: 549 sq. feet

The parcel of Louisiana land on which the house is located is in the midst of a rural landscape, between the two types of terrain characteristic of the region: a dense oak forest and a vast grassland. The area's sparse, rural population is scattered in small towns, on farms, and in a few vacation homes. Summers are very hot and humid, while winters are relatively mild, so the house was positioned to catch the prevailing winds. The combination of these factors and the clients' desires resulted in a building with basic lines, the product of a refined abstraction, closely related to the architecture typical of the region.

The clients, a recently retired couple, had had the property for many years, but had just recently decided to build a home there for use on weekends or short vacations. From the outset they emphasized their desire to participate in the construction of the house, which they saw as a basic, simple structure. The house is covered by two layers of material: an outer shell, that requires less precision in the finishings, protects against the elements and was installed by the clients themselves, and a more highly refined inner layer, which required the expertise of skilled workers. While the outer layer consists of a corrugated sheet and fiberglass window panels, the inner finish of plasterboard and oak provides this refuge with warmth.

The house consists of two main spaces, a living room and a bedroom, facing each other and connected by a deck. The plan is based on the typical regional architecture, in which two things are fundamental: aligning spaces along an axis and sectioning the structure to open it up to the landscape and ventilate the interior spaces naturally. A single, long roof covers the two spaces and the deck that cuts across the center of the building. Sliding doors integrate the interior spaces with each other and with the exterior.

STEPHEN ATKINSON
Zachary

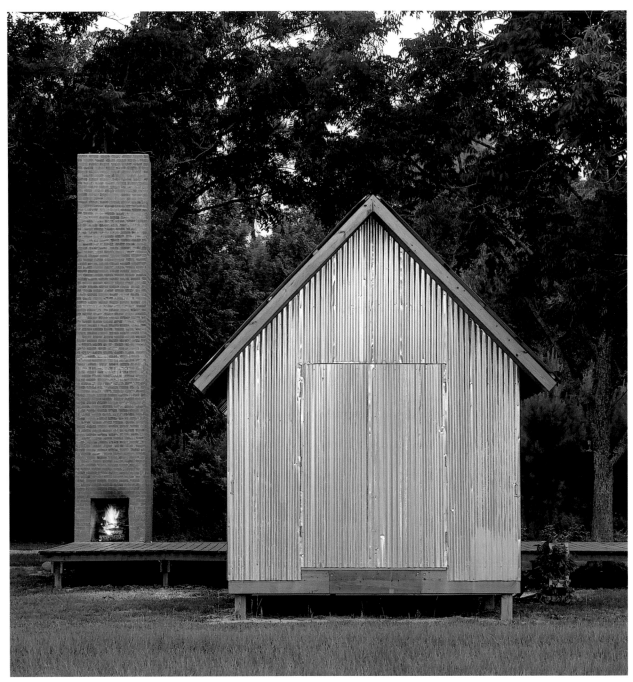

A vertical brick structure stands apart from the house, housing the barbecue and keeping the heat away from the interior.

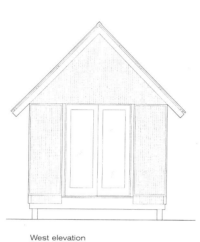

West elevation

Axonometric view of chimney

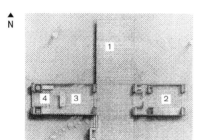

Plan

0 2 4

1. Deck
2. Bedroom
3. Living area
4. Kitchen

North elevation

Longitudinal elevation

Interior perspective

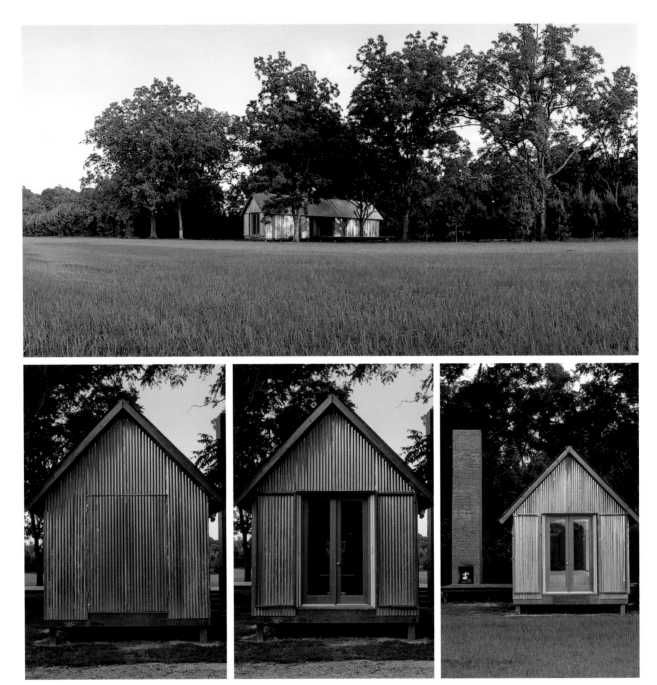

The doors and windows are also covered with corrugated metal sheeting, closing the house tight when it is unoccupied.

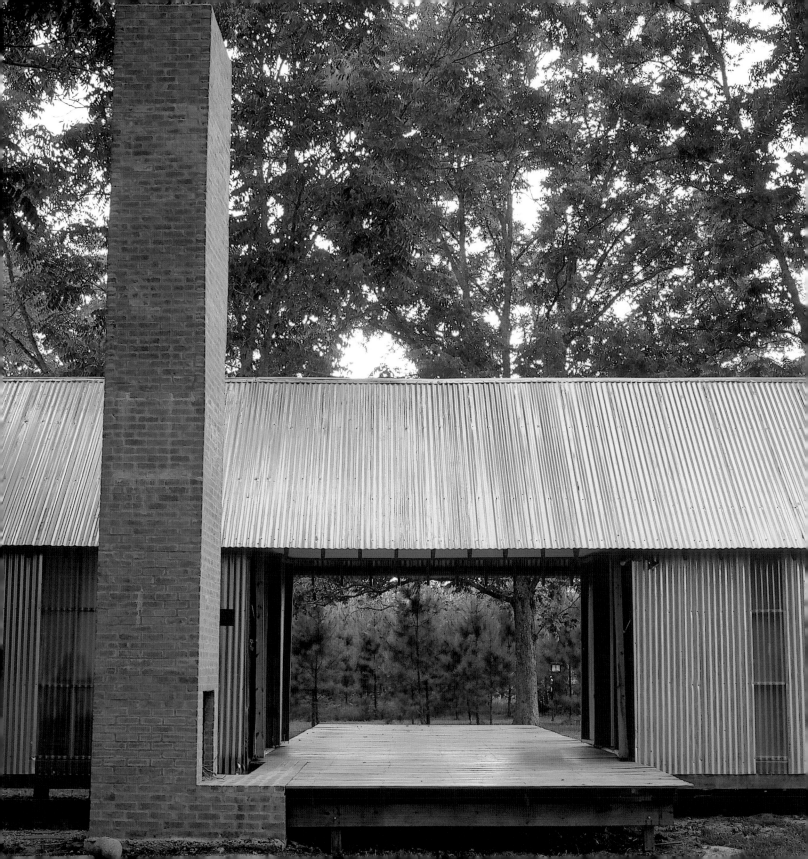

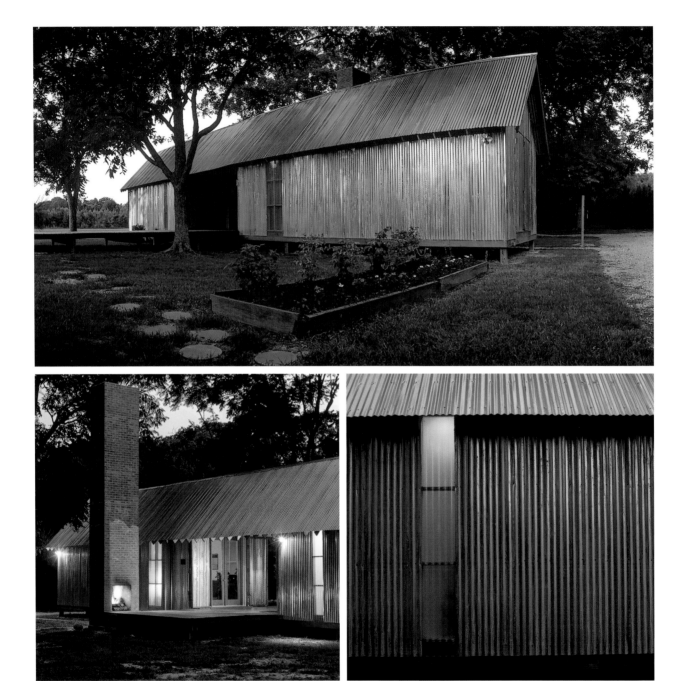

At right angles to the house, the deck, a wooden plataform which is raised slightly odd the ground and welcomes visitors, stretches away from the building.

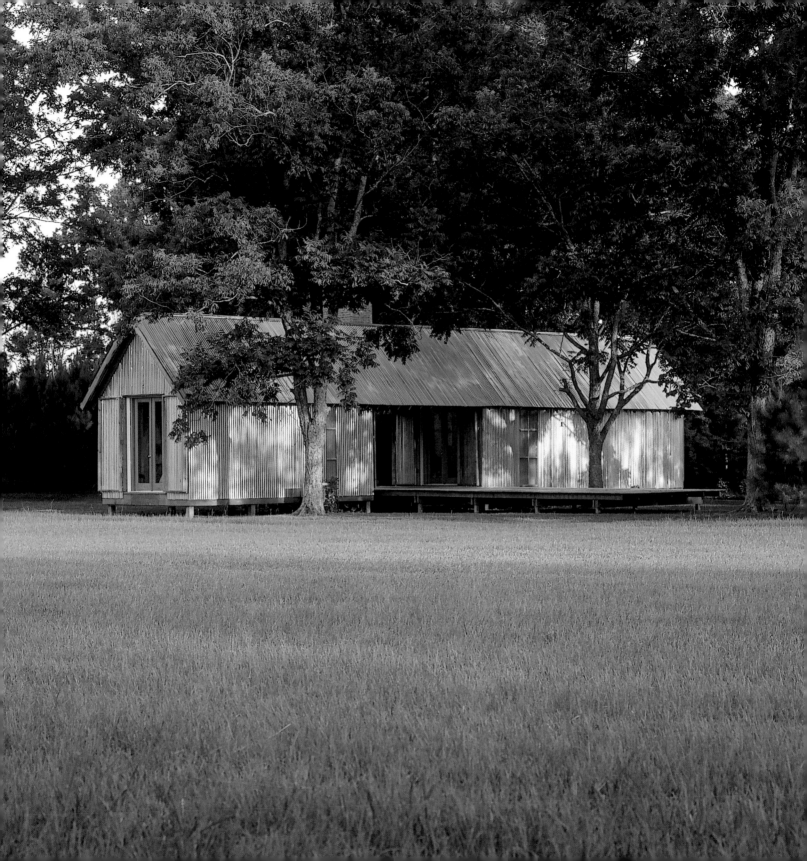

The interior details and finishes are more refined than those employed outside, so the space is comfortable and warm.

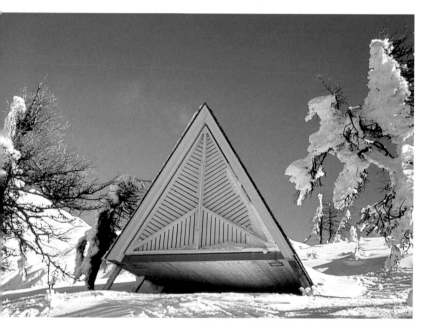

The basic shape of the house's design and the use of wood as the primary material reflect traditional alpine architecture.

Wenger

ROSSWALD, SWITZERLAND 1976 (ORIGINAL) 1996 (ALTERATION) ARCHITECT: HEIDI AND PETER WENGER PHOTOGRAPHY: © PETER WENGER AREA: 430 SQ. FEET

This house in the Swiss Alps, situated at an altitude of 21,520 feet, is a tiny vacation home that the architects designed as a place where they could spend short periods in the mountains. The isolated location and the building's nature as a temporary retreat determined the parameters for the design, in which both the interior and exterior function as objects that can be opened up for use for a variety of situations. The windows, doors, balconies, tables, chairs, and kitchen furnishings can be opened up, changing the feel from one of enclosure to one of openness and total integration with the exterior.

The framework, a simple system of sloping beams, marks the interior space and gives the house its nickname: Trigon. It has the same shape as the roofs of the region's traditional houses, but in this case, the main part of the house seems to be missing, as if it were buried by snow. The primary material, wood, is used for both the structural elements and the interior finishings. Special care was taken with all the components to create more than a house: a small-scale mechanical object that functions with great precision.

The basic plan consists of two floors and a single space. The lower level houses the living room, dining room, and kitchen, while the upper level, joined to the lower level, attic-like, by a spiral staircase, contains the bedroom. When the house is occupied, the western façade, which is also a wooden platform, opens fully to create a balcony extending from the living room. Inside, other fold-out elements, such as the dining room chairs, the central kitchen cabinets, and the triangular doors in the outer wall, make the space truly multifunctional.

HEIDI AND PETER WENGER
House

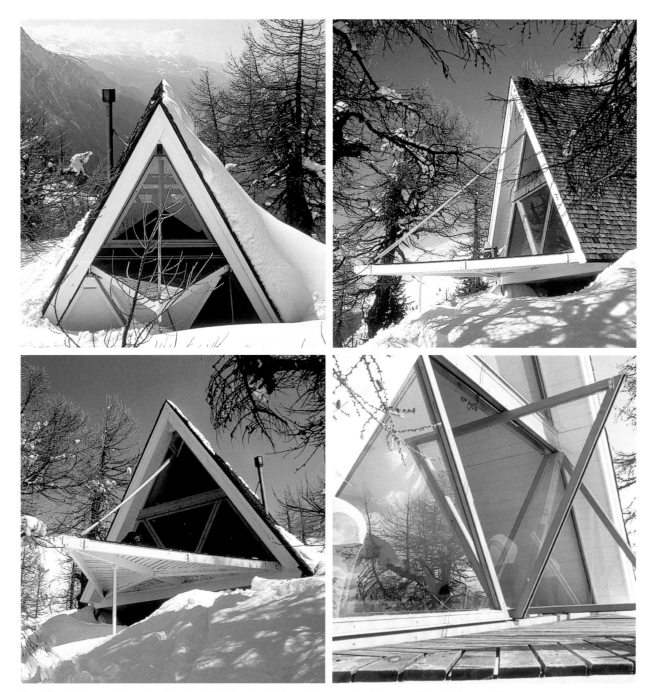

The fold out balcony on the western façade and the triangular pivoting windows create a rich composition of juxtaposed planes.

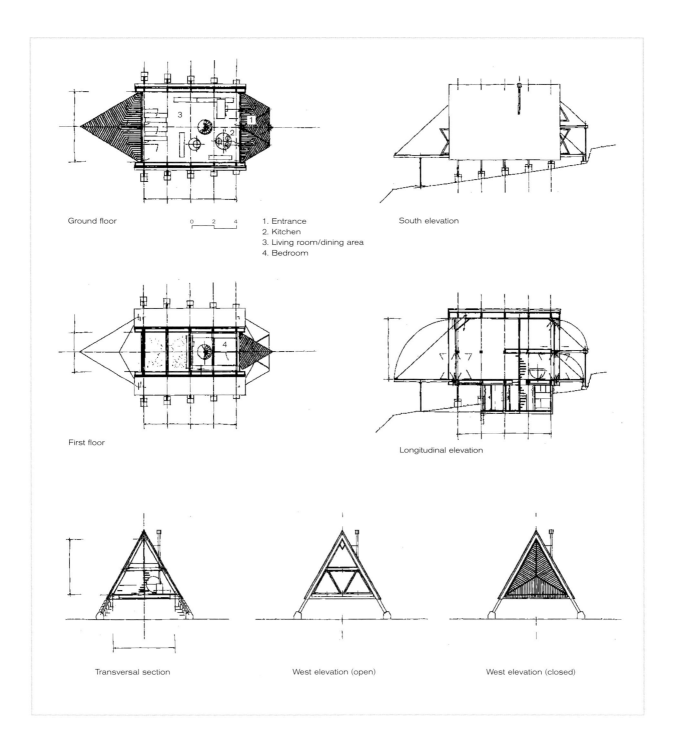

Ground floor

0 2 4

1. Entrance
2. Kitchen
3. Living room/dining area
4. Bedroom

South elevation

First floor

Longitudinal elevation

Transversal section

West elevation (open)

West elevation (closed)

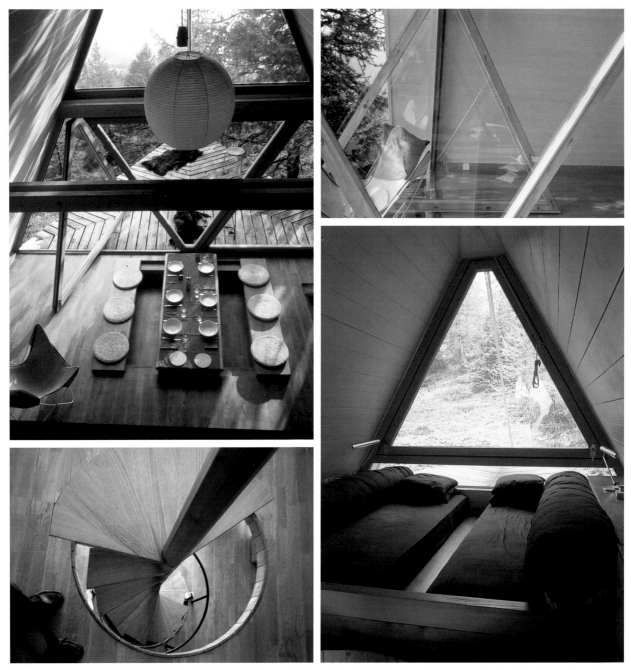

To make the most of the minimal interior space, unnecessary decorative pieces and furnishings were avoided. The architecture itself provides for the home's various needs.

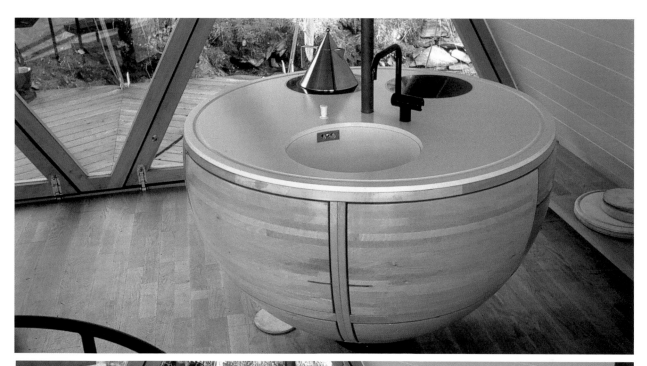

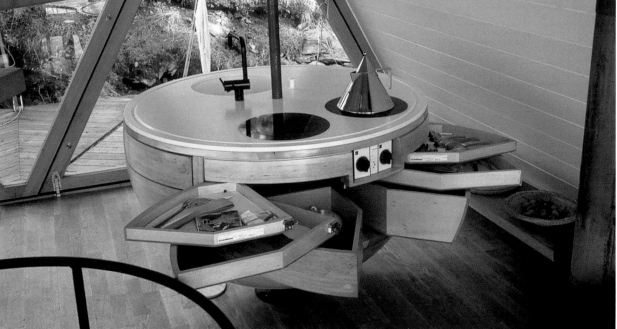

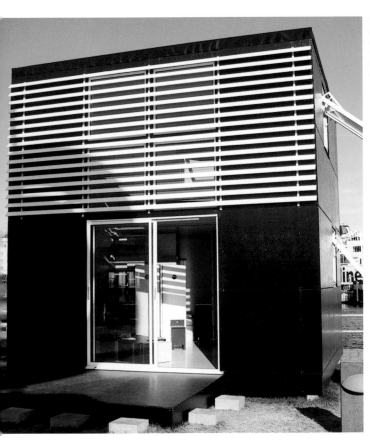

The building's proportions and the arrangement of the exterior walls, the filled spaces and the empty spaces, are all a function of the structural system. The square shape of the chipboard panels emphasizes the project's shape.

Black

HALMSTAD, SWEDEN 1999 ARCHITECT: ANDREAS HENRIKSON PHOTOGRAPHY: © ANDREAS HENRIKSON AREA: 355 SQ. FEET

"Black box" is the name that was given to this project, consisting of a small, mobile, multifunctional home, because of its outward appearance which, according to the architect, resembles a magician's box. The idea was an initiative of the architect, who both designed and built the project. His challenge was to come up with a structure that could be set up anywhere and was suitable for different purposes. The box can be used as a small getaway, study, summer house, pavilion, office, or a student's home. Each owner can decide on the utilization in accordance with his or her needs and location.

The structure consists of a simple system of light wooden frames that form a three-dimensional orthogonal weave covered by ninety square chipboard panels. Each panel has a layer of plywood on both sides. Due to their proportions and assembly mechanisms of the panels, constructing and dismantling the box is an easy task. The roof is covered with a membrane of high-quality rubber that protects the house from climatic variables and water.

The architect wanted to create a dwelling that was both spatially flexible and energy self-sufficient. The interior is a medium-sized two-story space. An open space on the upper level serves as a sleeping or work area. Below it are the services, kitchen, bathroom, and stairs, which are on one side of the cube. The house is not connected to any utility systems. Electrical power installations, water, and waste are held in containers, adjacent to an outer wall, that can meet the house's needs for extended periods.

ANDREAS HENRIKSON

Box

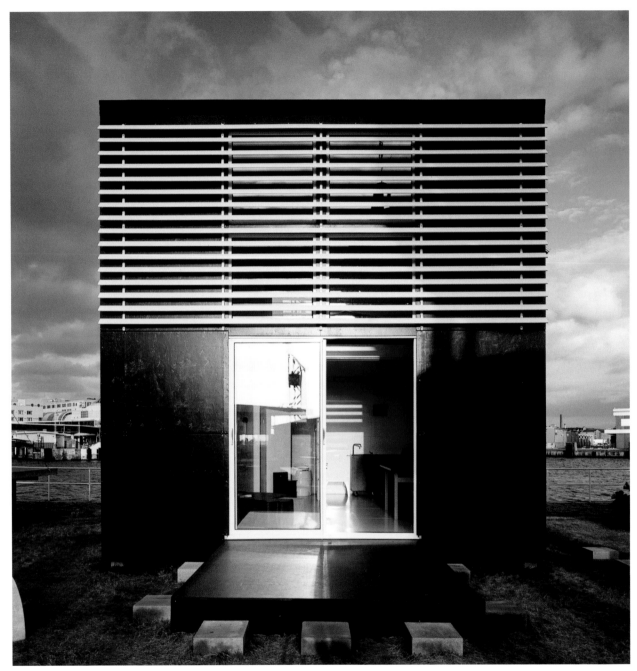

The platform at the entrance and the blinds on the upper level can be adjusted in accordance with how the building is being used or the amount of light desired.

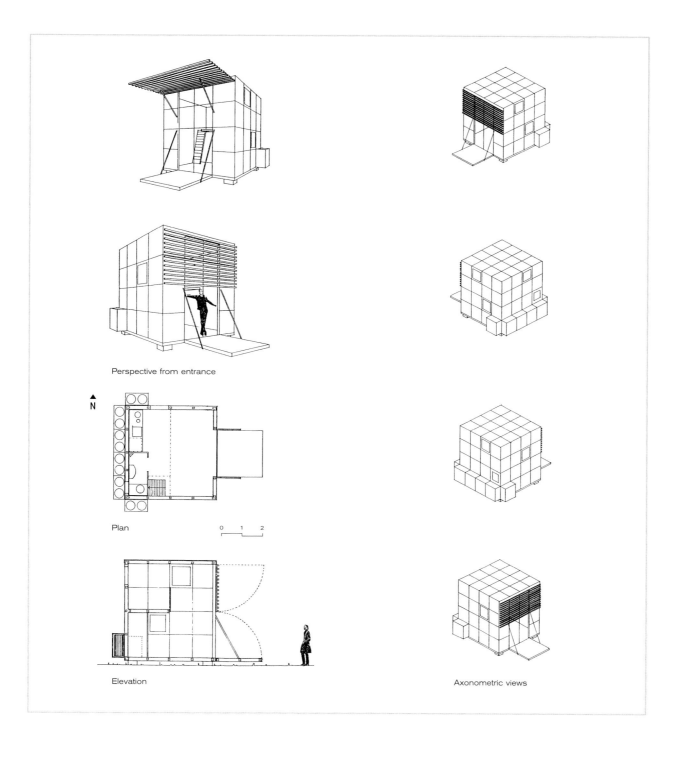

Perspective from entrance

Plan

0 1 2

Elevation

Axonometric views

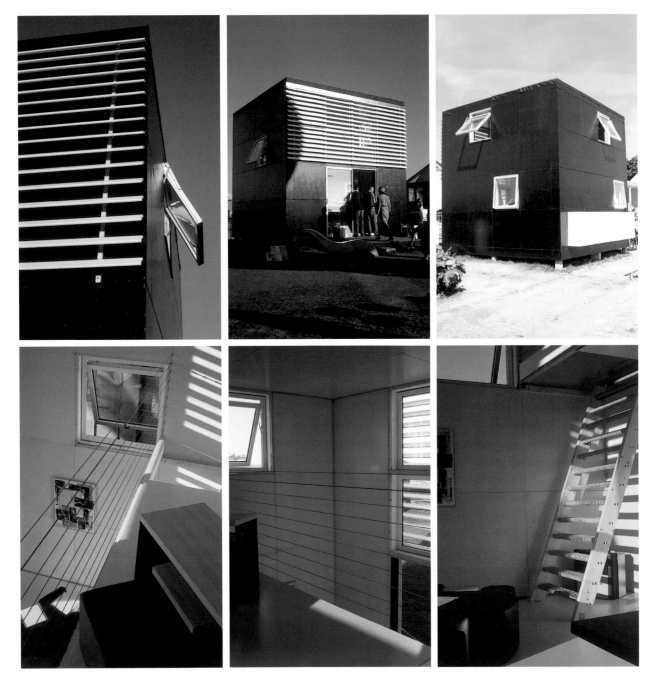

Inside the wood surfaces and the light colors contrast with the exterior to create a warm, inviting atmosphere.

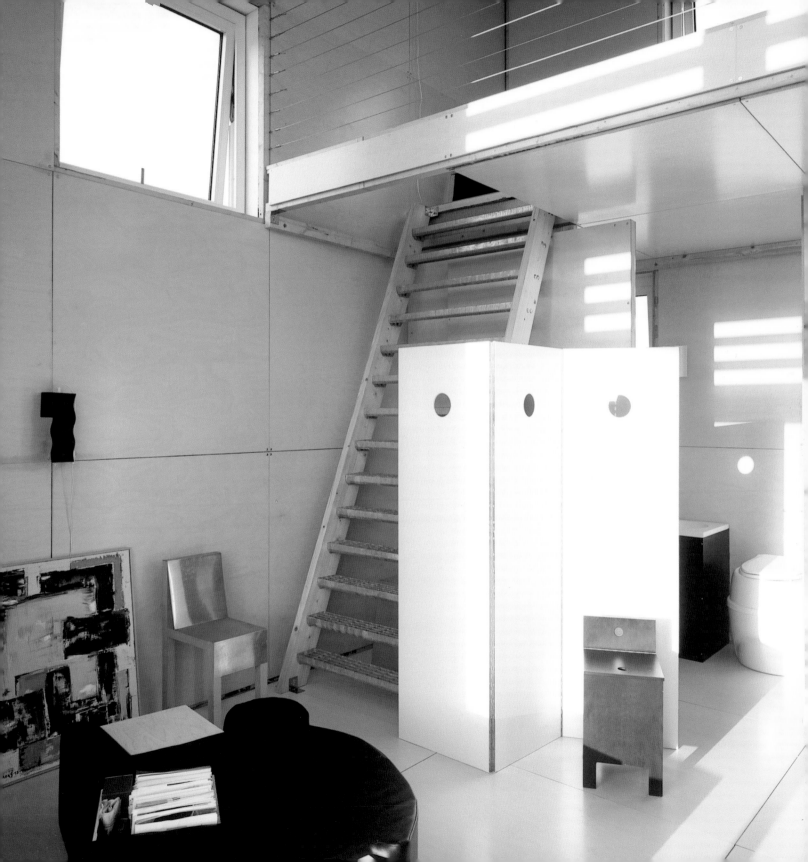

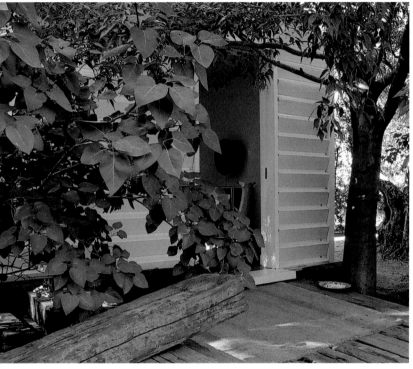

Although it is a temporary structure, the house is subtly integrated with its surroundings. The coldest materials, such as perforated sheet metal, are combined with wood to produce a practical, inviting building.

Complete House

Madrid. Spain 2001 Interior designer: Javier Sol + Juan Manuel Fernández + Ana López / O.T.O. Estudio
Collaborators: Gunni (kitchen, bath, and storage closet) Photography: © Ricardo Labougle Area: 344 sq. feet

This prefabricated house recreated a tiny home for an annual interior design expo in Madrid. The exterior structure, which takes as a point of departure the old olive grove in the midst of the city, serves as a framework for an interior design project that solves the problems created by the minimal space. Essentially, it is a small wooden-framed box covered on the outside by sheet metal and on the inside by panels of wood chipboard. The most important architectural feature is the inclined plane, actually an extension of the roof that comes all the way to the ground, with its large wooden frames that enclose vast windows which complete the integration of the olive grove and the interior space.

To guarantee the comfort and efficiency of life in such a small space, the designers employed cutting-edge technology. The sleeping area includes a panel of microperforated chipboard for greater sound absorption. The kitchen, which had to be fully integrated with the space, was custom designed for this house. A system of panels inspired by the work of Mondrian hide the small, built-in kitchen and open up with just a touch. The system makes it possible to use the entire kitchen or hide all or parts of it, such as the bell extractor that emerges when a button on the counter is pushed.

The designers refined the interior details by mixing contemporary and classical elements. They selected oak for the floor and a single pastel shade for the walls, unifying the space and providing a backdrop for the different pieces of furniture. The furniture placement marks off and defines the minimal interior space, and the dining room, kitchen, living room, bedroom, storage closet, and bathroom succeed each other to optimize traffic flow by concentrating it in the center.

Javier Sol + Juan Manuel Fernández + Ana López / O.T.O.
in 344 sq. feet

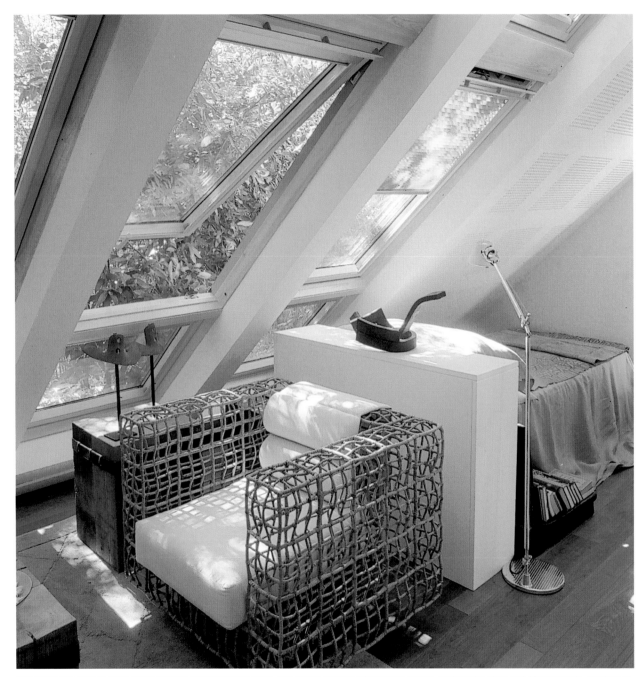

Contemporary objects, such as the kitchen appliances and lights, and classic or ethnically-inspired pieces, such as the chair and African stools, combine to make the interior both functional and welcoming.

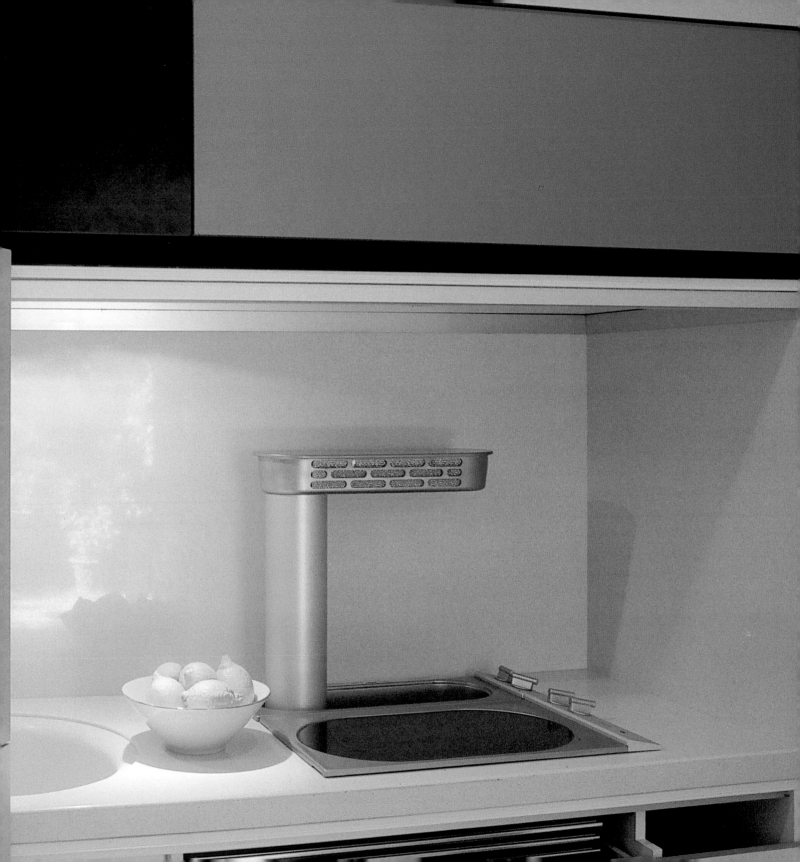

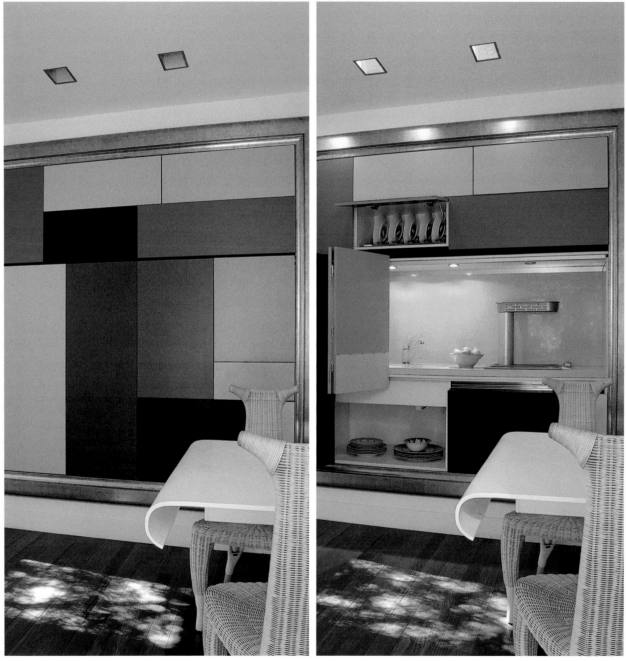

The kitchen is fully integrated into the space through its system of movable panels. Due to the play of colors, it is also a very striking decorative element.

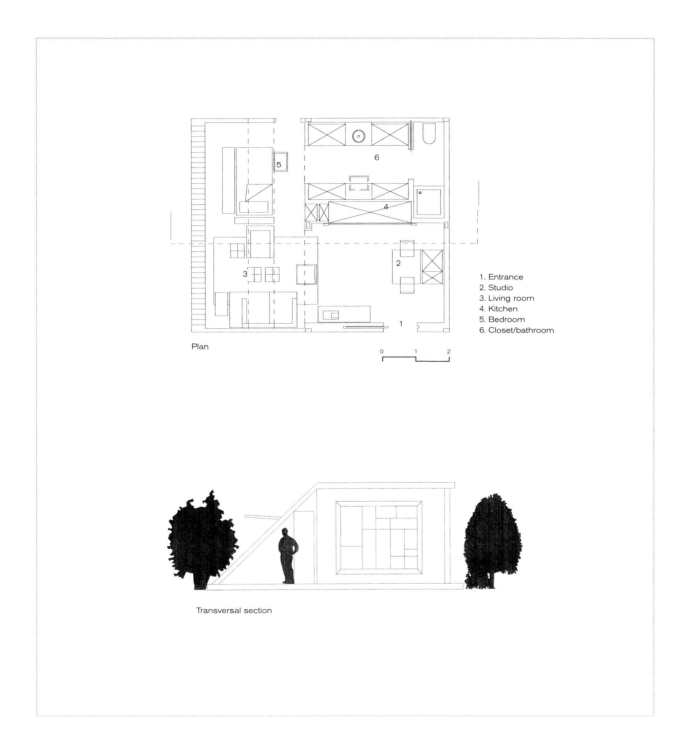

Plan

1. Entrance
2. Studio
3. Living room
4. Kitchen
5. Bedroom
6. Closet/bathroom

0 1 2

Transversal section

While the area with the best lighting was used for the living spaces, the most enclosed and private area was used for the storage closet and bathroom.

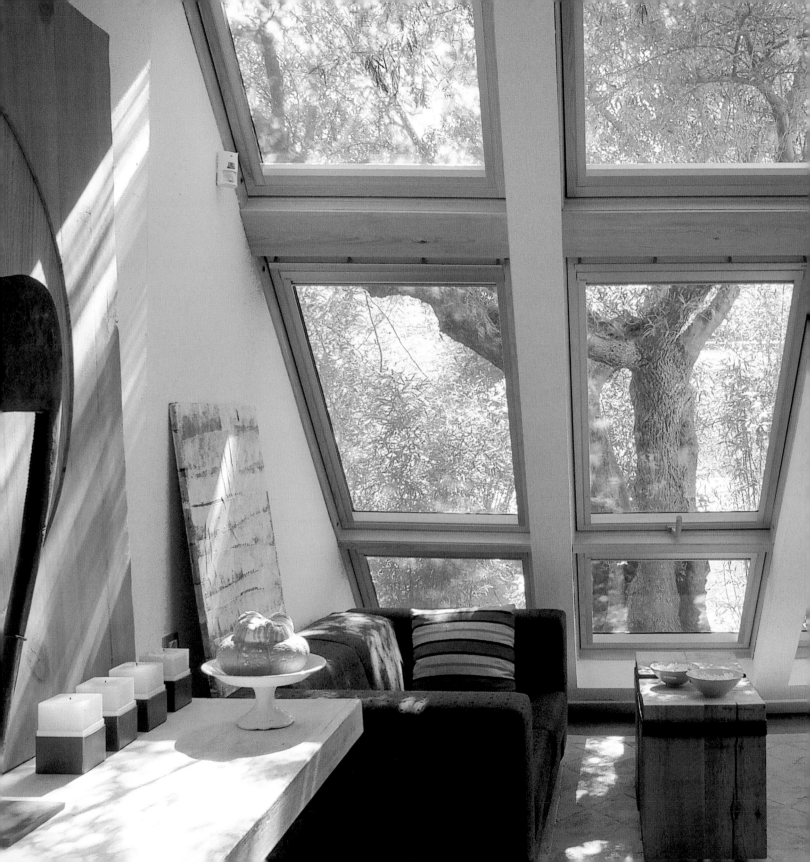

10 ELEKTRA HOUSE — David Adjaye
Adjaye / Associates
23-28 Penn Street
London N1 5DL
United Kingdom
Tel.: +44 207 739 4969
Fax: +44 207 739 3484
dadjaye@compuserve.com

18 HOUSE IN
TORRELLES — Rob Dubois
Av. Verge del Puig 9
08470 Sant Celoni
Barcelona, Spain
Tel.: +34 93 867 5801
rob.dubois@coac.es

26 MOOSMANN-
HÄMMERLE
HOUSE — Hermann Kaufmann
Sportplatzweg 5
6858 Schwarzach, Austria
Tel.: +43 5572 58174
Fax: +43 5572 58013
office@archbuero.at
www.kaufmann.archbuero.com

34 OFFICE HOUSE — Desai / Chia Studio
54 West 21st Street, 7th Floor
New York, NY 10010, USA
Tel.: +1 212 366 9630
Fax: +1 212 366 9278

40 MODEL PLASTIC
RESIDENCE — Masao Koisumi / C+A
Coelacanth and Associates
4F Kyuseigun-Bldg., 1-20-5
Ebisu-nishi, Shibuya-ku
Tokyo 150-0021, Japan
Tel.: +81 3 5489 8264
Fax: +81 3 5458 6117
akune@c-and-a.co.jp
www.c-and-a.co.jp

46 HOUSE ON
MOUNT FUJI — Satoshi Okada
Satoshi Okada & atelier a+a
16-12-303 Tomisha-cho
Shinjuku, Tokyo
162-0067, Japan
Tel.: +81 3 3356 0646
Fax: +81 3 3355 0658
okadas@cb.mbn.or.jp

52 TOWER HOUSE — Frederick Phillips
Frederick Phillips and
Associates, Architects
1456 North Dayton Street
Suite 200,
Chicago, Illinois 60622, USA
Tel.: +1 312 255 0415

56/82 VACATION HOME
IN FURX/
STEINHAUSER
HOUSE — Marte.Marte Architekten
Totengasse 18
6833 Weiler, Austria
Tel.: +43 5523 52587
Fax: +43 5523 52587

64 DODDS HOUSE — Engelen Moore
44 Mclachlan Avenue
Rushcutters Bay, Sydney
2011 Australia
Tel.: +61 2 9380 4099
Fax: +61 2 9380 4302
nm@engelenmoore.com.au

70 SUMMER
RESIDENCE AND
GALLERY — Henning Larsens Tegnestue
Vesterbrogade 76, DK 1620
Copenhagen, Denmark
Tel.: +45 82 33 30 00
Fax: +45 82 33 30 99
hlt@hlt.dk
www.hlt.dk

76 SOIVIO BRIDGE — Jukka Siren
Tiirasaarentie 35
00200 Helsinki, Finland
Tel.: +358 9 6811 6800
Fax: +358 9 6811 6811
jukka.siren@srenarkkitehdit.fi

92 ITHACA HOUSE — Simon Ungers
An den Kastanien 1
50859, Cologne, Germany
Tel.: +49 221 1709814
Fax: +49 221 1709814

mini
house